places in

National
Gallery

Happy Birthday Cate,
love from Uncle Stuu and
Aunt Barbara — June 2002

D0980231

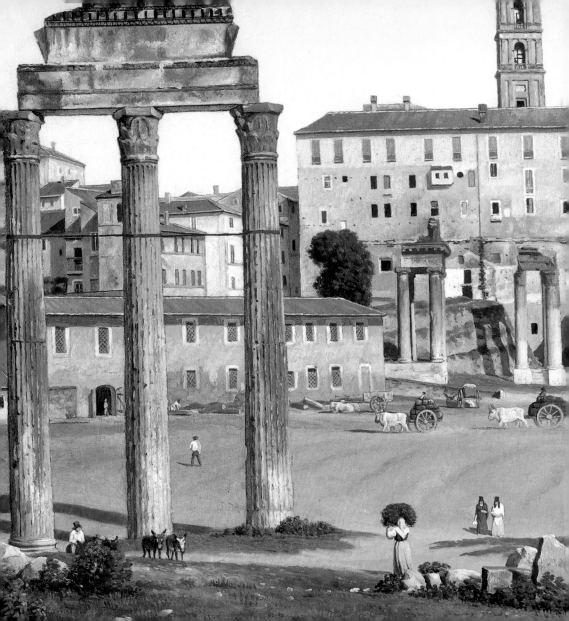

places in

National
Gallery

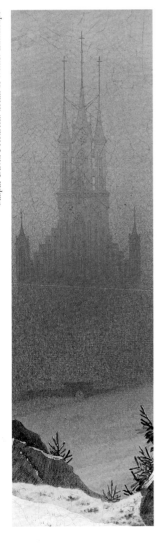

Caspar David Friedrich: detail of *Winter Landscape*

First published in the United States in 1998 by
Watson-Guptill Publications, Inc.
a division of BPI Communications, Inc.
1515 Broadway
New York, NY 10036

Series Editor: Ljiljana Ortolja-Baird
Designer: Bet Ayer

Library of Congress Catalog Card Number: 98-85855

ISBN: 0-8230-0336-1

First published in the United Kingdom in 1998 by
MQ Publications, Ltd.
254–258 Goswell Road
London EC1V 7EB

Printed and bound in Italy

1 2 3 4 5 6 7 8 / 05 04 03 02 01 00 99 98

Title page: Christoffer Wilhelm Eckersberg, detail of *View of the
Forum in Rome*

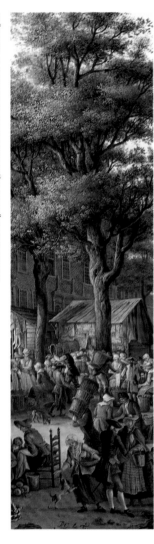

Paulus Constantijn La Fargue: detail of *The Grote Markt at The Hague*

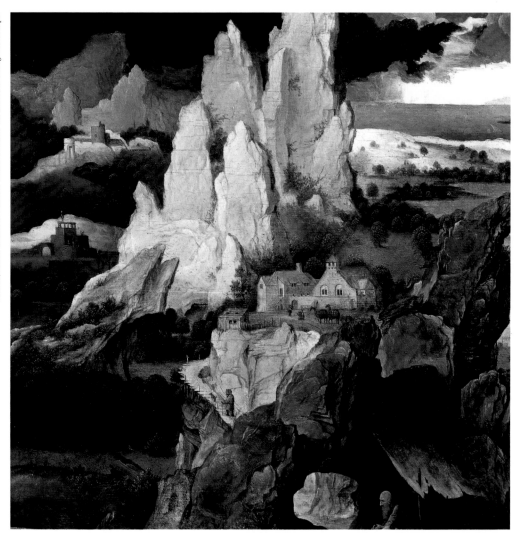

INTRODUCTION

'As painting, so poetry'. Like all siblings, the Sister Arts are rivals and allies. In the mirrors they hold up to nature we see ourselves reflected from varying angles and by different lights.

The National Gallery in London houses some of the finest European paintings in the world. Many record the places where men and women have spent their lives: working, listening to music, enjoying each other's company or the fleeting beauty of flowers and sunshine, taking pride in well-tilled fields and bustling cities. Others depict dream voyages through time and space, paradises lost and utopias gained. Writers in turn, have kept diaries, celebrated familiar or exotic sights, evoked lands unseen.

By exploring the paintings in detail, often discovering aspects we never 'knew' were there, and by the pairing of text and image in sometimes unexpected yet always apt combinations, *Places in Art* enhances the descriptive powers of both painting and literature, encouraging us to hone our responses to each.

Erika Langmuir
Head of Education, National Gallery, 1988–1995

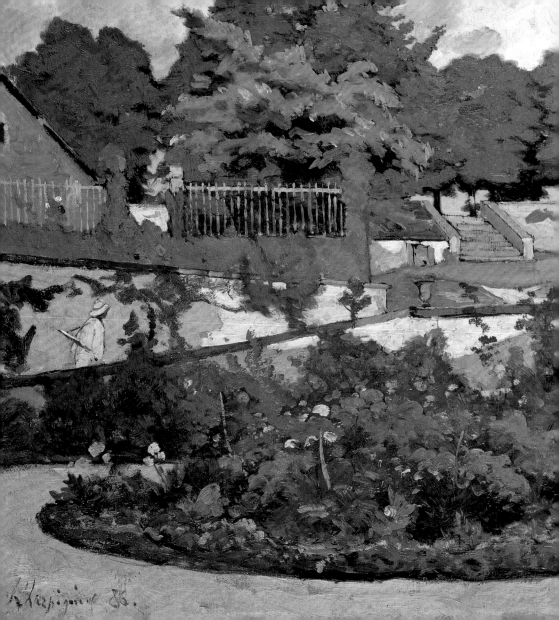

parks & gardens

EDOUARD MANET
(1832–1883) French
*Music in the Tuileries
Gardens*
1862

The crowd is his element,
as the air is that of birds
and water of fishes. His
passion and his profession
are to become one flesh
with the crowd. For the
perfect *flâneur*, for the
passionate spectator, it is
an immense joy to set up
house in the heart of the
multitude, amid the ebb
and flow of movement, in
the midst of the fugitive
and the infinite.

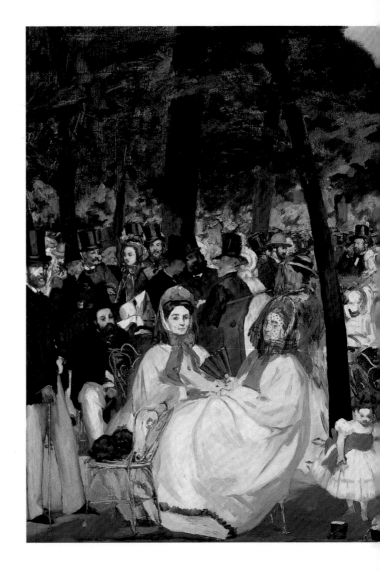

To be away from home
and yet to feel oneself
everywhere at home; to see
the world, to be at the
centre of the world, and yet
to remain hidden from the
world – such are a few of
the slightest pleasures
of those independent,
passionate, impartial
natures which the tongue
can but clumsily define.
The spectator is a *prince*
who everywhere rejoices in
his incognito. The lover of
life makes the whole world
his family, just like the
lover of the fair sex who
builds up his family from all
the beautiful women that he
has ever found; or that are
– or are not – to be found;
or the lover of pictures who
lives in a magical society of
dreams painted on canvas.

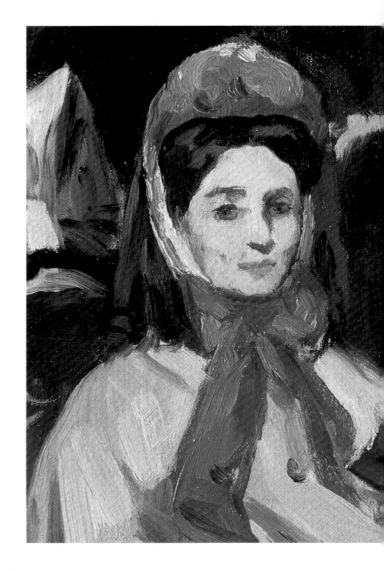

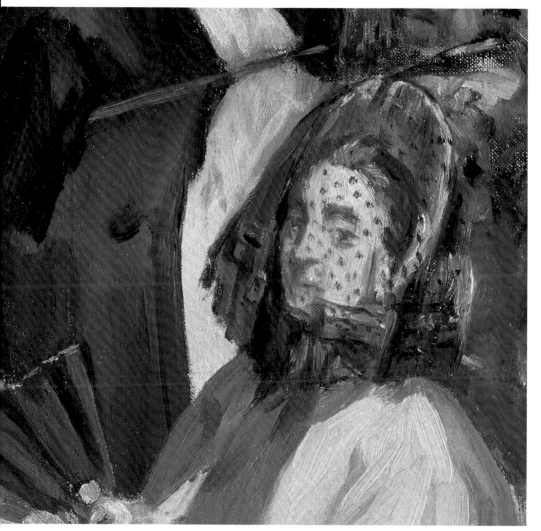

13

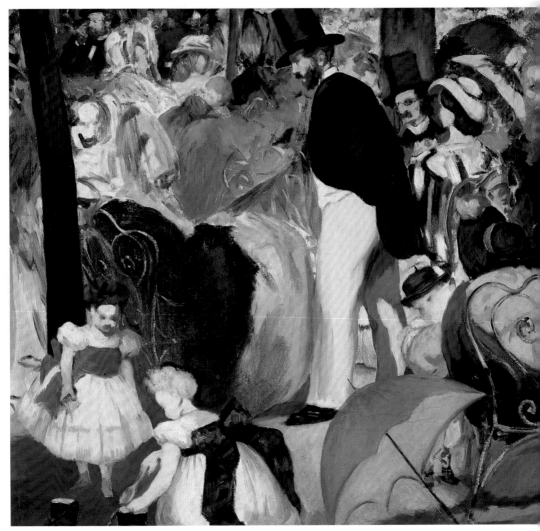

14

Thus the lover of universal life enters into the crowd as though it were an immense reservoir of electrical energy. Or we might liken him to a mirror as vast as the crowd itself; or to a kaleidoscope gifted with consciousness, responding to each one of its movements and reproducing the multiplicity of life and the flickering grace of all the elements of life.

from *The Painter of Modern Life*,
CHARLES BAUDELAIRE, 1863

CLAUDE-OSCAR MONET
(1840–1926) French
Bathers at La Grenouillère
1869

A servant appeared and
lunch was ordered. 'Fried
river fish, stewed rabbit,
salad, and a sweet,'
announced Madame
importantly. 'And bring
two litres of draught wine
and a bottle of claret,'
added her husband. 'And
we'll lunch on the grass,'
went on the girl...

'Look here!' cried the
tow-haired youth, who was
poking about the yard,
'here are some top-hole
boats!' They all went to
look. Under a little
wooden shed were hanging
two lovely racing skiffs,
beautifully built and as
carefully finished as the
most expensive furniture.

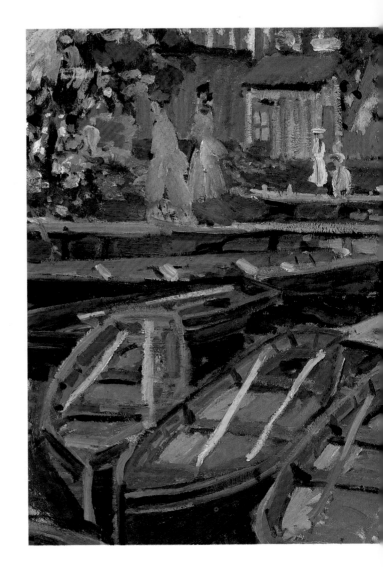

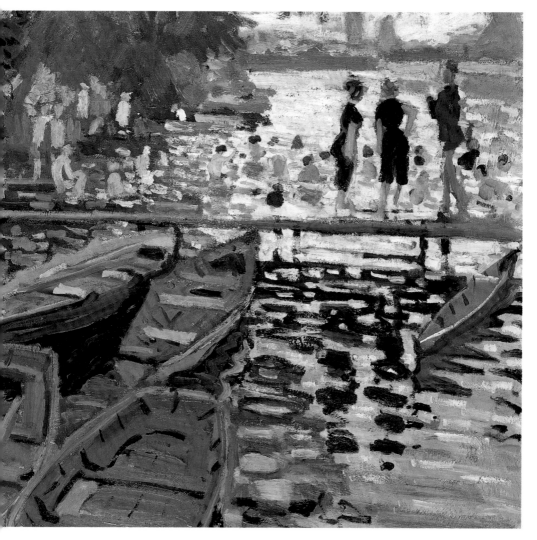

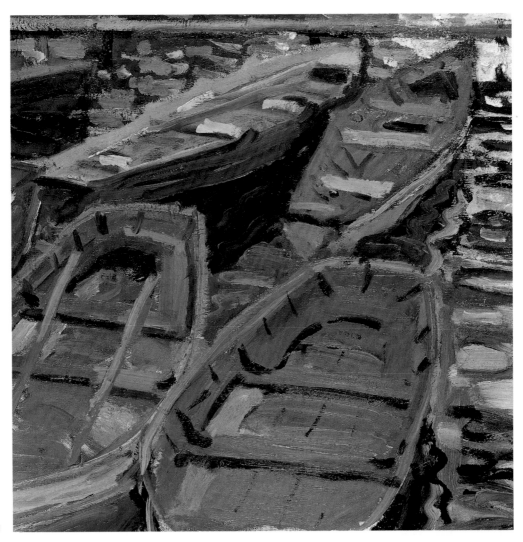

There they were, lying side by side like two tall girls, long, narrow in the beam, and highly varnished. The very sight of them made you long to glide over the water on a fine warm evening or bright morning in summer, skimming past flowery banks, where tall trees dip their branches in the water, while the whisper of the rushes never ceases and kingfishers dart about like flashes of blue lightning.

The whole family examined them, duly impressed. 'Yes, they're top-hole,' repeated M. Dufour sententiously, and he proceeded to enumerate their points. He had rowed himself as a young man, he went on; indeed with an oar like that in his hand – and he went through the motions of rowing – he would take anyone on. He had beaten several Englishmen in the old days sculling at Joinville; and he had made puns on the word 'dames'(ladies), the technical term for rowlocks, saying that of course oarsmen never went out without their 'ladies'. In an eloquent peroration he declared himself ready to bet that in a boat like that he would cover fifteen miles in an hour with ease.

'Lunch is ready,' cried the waitress, appearing at the entrance to the shed.

<div align="right">

from *A Picnic in the Country*,
GUY DE MAUPASSANT, 1881

</div>

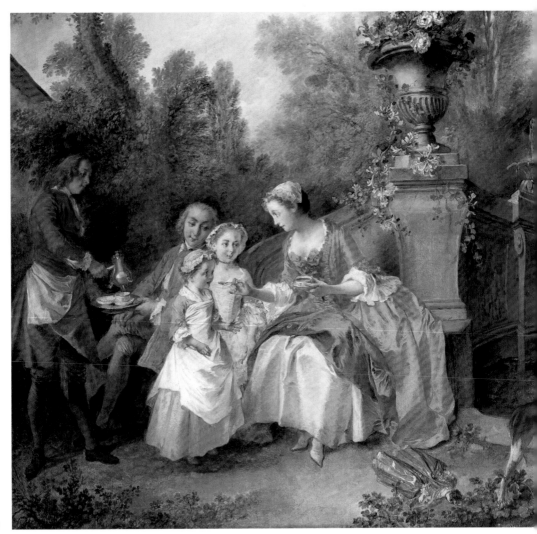

NICOLAS LANCRET (1690–1743) French
A Lady in a Garden taking Coffee with some Children
probably 1742

I saw a thousand dazzling wild flowers, among which my eye with surprise distinguished some garden flowers, which seemed to grow naturally with the others ... I followed winding and irregular walks bordered by these flowery thickets and covered with a thousand garlands of woody vines ...

'You see nothing laid out in a line,' [said Monsieur de Wolmar]. 'The carpenter's line never entered this place. Nature plants nothing by the line. The simulated irregularities of the winding paths are artfully managed in order to prolong the walk, hide the edges of the island, and enlarge its apparent size, without creating inconvenient and excessively frequent turnings.'

Considering all this, I found it rather curious that they should take so much trouble to hide that very trouble which they had taken. Would it not have been better to have taken none at all?

'In spite of all you have been told,' Julie answered me, 'you are judging the work by the effect, and you deceive yourself. All that you see are wild or sturdy plants, which need only to be put in the ground and which then come up by them-selves...Those who love nature and cannot go seek it so far away are reduced to doing it violence, to forcing it in some manner to come dwell with them, and all this cannot be effected without a little illusion.'

from *Julie, ou la Nouvelle Héloïse,*
JEAN-JACQUES ROUSSEAU, 1761

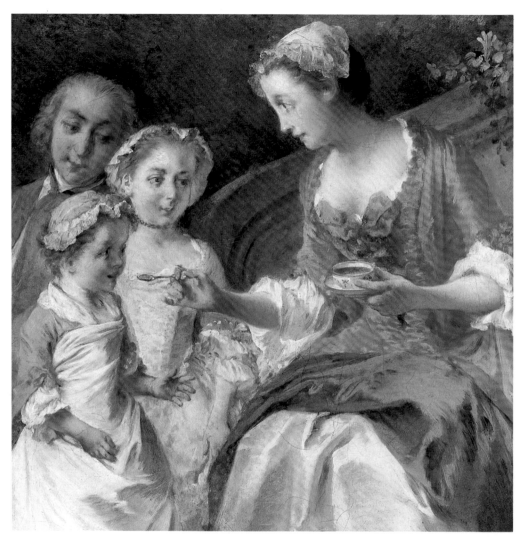

23

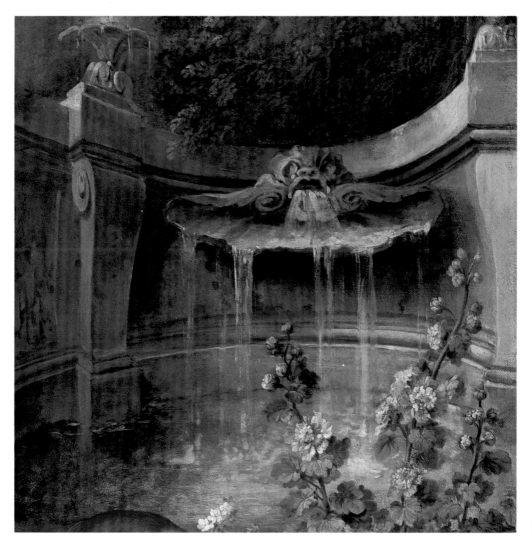

25

STYLE OF MARTIN SCHONGAUER
(Martin Schongauer, active 1469; died 1491, German)
The Virgin and Child in a Garden
1469–91

The rose in a mystery—where is it found?
Is it anything true? Does it grow upon the ground?
It was made of earth's mould but it went from men's eyes
And its place is a secret and shut in the skies.
> *In the gardens of God, in the daylight divine*
> *Find me a place by thee, mother of mine.*

Is Mary the rose then? Mary the tree?
But the blossom, the blossom there, who can it be?—
Who can her rose be? It could be but one:
Christ Jesus our Lord, her God and her son.
> *In the gardens of God, in the daylight divine*
> *Shew me thy son, mother, mother of mine.*

What was the colour of that blossom bright?—
White to begin with, immaculate white.
But what a wild flush on the flakes of it stood
When the rose ran in crimsonings down the cross-wood!
> *In the gardens of God, in the daylight divine*
> *I shall worship His wounds with thee, mother of mine.*

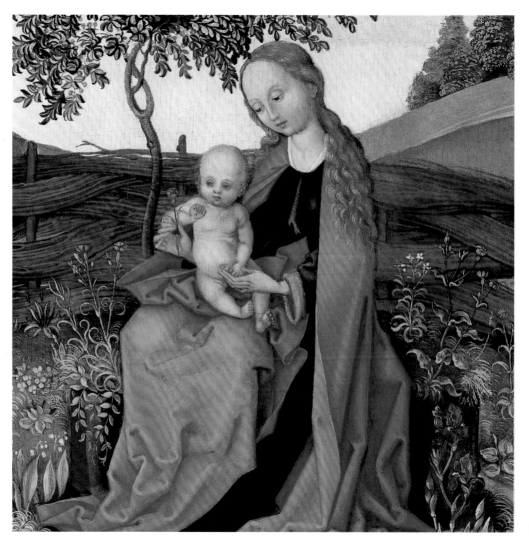

How many leaves had it?—Five they were then,
Five like the senses and members of men;
Five is their number by nature, but now
They multiply, multiply who can tell how?
 In the gardens of God, in the daylight divine
 Make me a leaf in thee, mother of mine.

Does it smell sweet too in that holy place?—
Sweet unto God, and the sweetness is grace:
O breath of it bathes great heaven above
In grace that is charity, grace that is love.
 To thy breast, to thy rest, to thy glory divine
 Draw me by charity, mother of mine.

from *Rosa Mystica*,
GERARD MANLEY HOPKINS, 1875

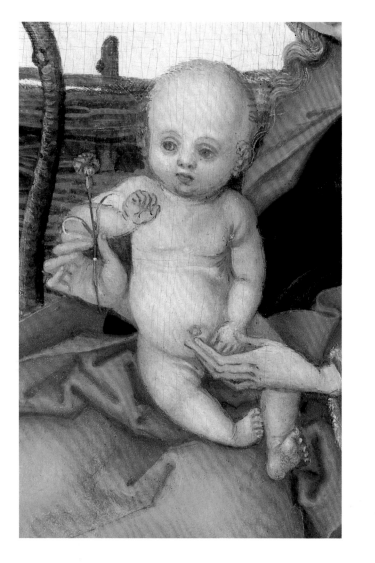

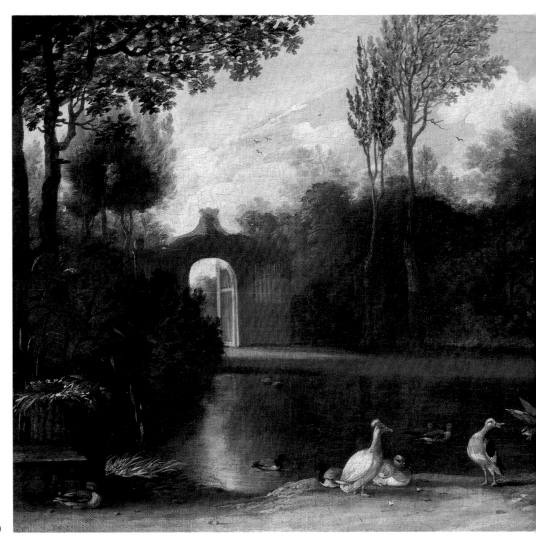

ANTHONIE VAN BORSSUM (1630–1677) Dutch
A Garden Scene with Waterfowl
probably about 1660–65

Whither, 'midst falling dew,
While glow the heavens with the last steps of day,
Far, through their rosy depths, dost thou pursue
 Thy solitary way?

Vainly the fowler's eye
Might mark thy distant flight, to do thee wrong,
As, darkly seen against the crimson sky,
 Thy figure floats along.

Seek'st thou the plashy brink
Of weedy lake, or marge of river wide,
Or where the rocking billows rise and sink
 On the chaféd ocean side?

There is a Power, whose care
Teaches thy way along that pathless coast,—
The desert and illimitable air,
 Lone wandering, but not lost,

All day thy wings have fanned,
At that far height, the cold, thin atmosphere;
Yet stoop not, weary, to the welcome land,
 Though the dark night is near.

And soon that toil shall end,
Soon shalt thou find a summer home, and rest,
And scream among thy fellows; reeds shall bend,
 Soon, o'er thy sheltered nest.

from *To a Waterfowl*,
WILLIAM CULLEN BRYANT, 1818

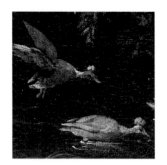

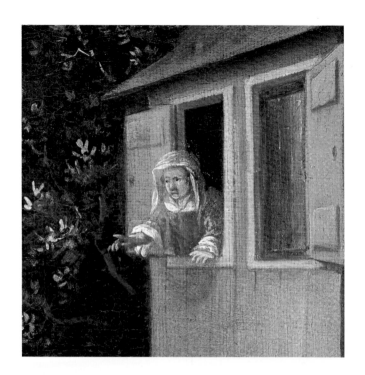

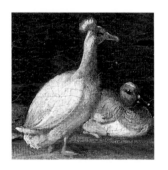

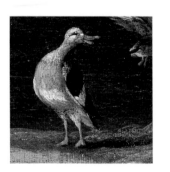

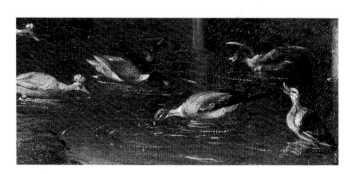

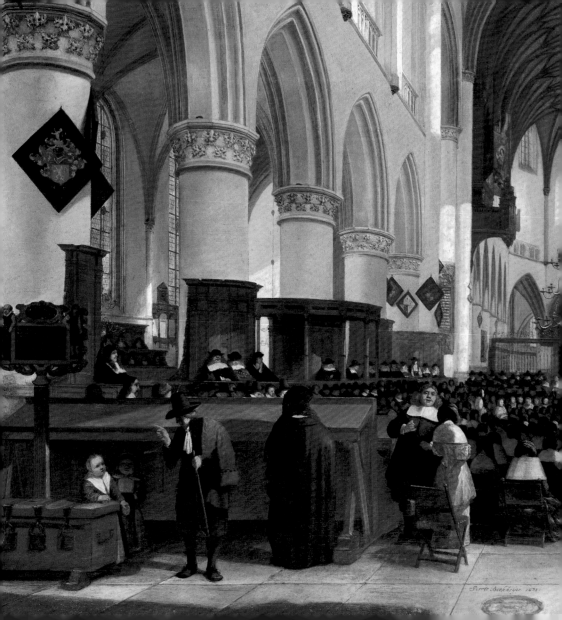

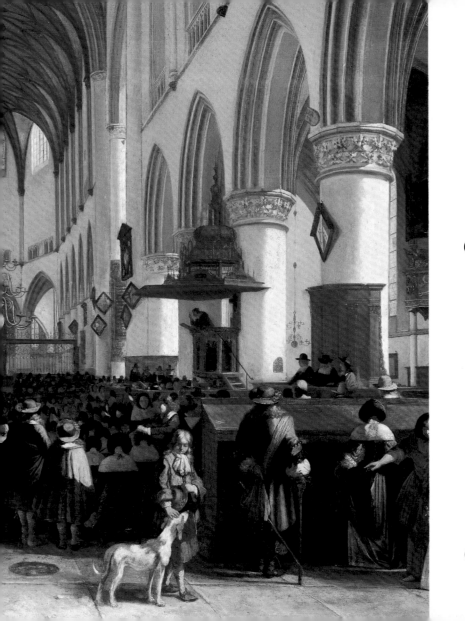

35

CANALETTO
(1697–1768) Italian
*London: Interior of the
Rotunda at Ranelagh*
1754

We have at last celebrated
the Peace, and that as
much in extremes as we
generally do everything,
whether we have reason to
be glad or sorry, pleased or
angry. Last Tuesday it
was proclaimed: The King
did not go to St. Paul's,
but at night the whole
town was illuminated. The
next day what was called
'a jubilee-masquerade in
the Venetian manner' at
Ranelagh: it had nothing
Venetian in it, but was by
far the best understood
and the prettiest spectacle
I ever saw: nothing in a
fairy tale ever surpassed it.

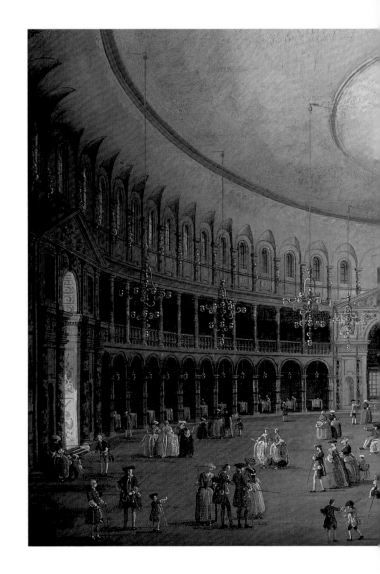

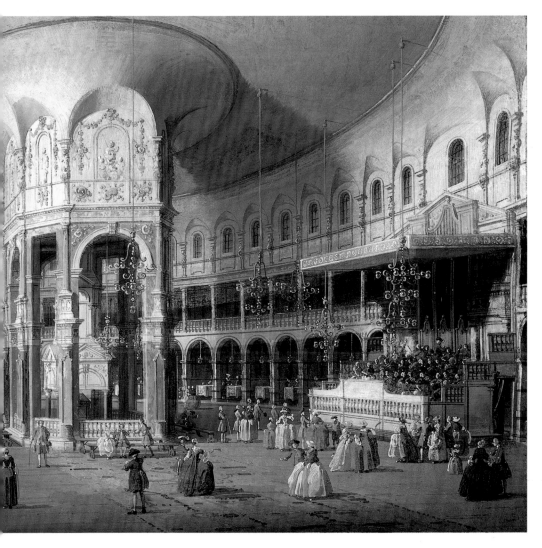

One of the proprietors, who is a German, and belongs to Court, had got my Lady Yarmouth to persuade the King to order it. It began at three o'clock, and, about five people of fashion began to go. When you entered, you found the whole garden filled with masks and spread with tents, which remained all night *very commodely*. In one quarter, was a May-pole dressed with garlands, and people dancing round it to a tabor and pipe and rustic music, all masqued, as were all the various bands of music that were disposed in different parts of the garden; some like huntsmen with French horns, some like peasants, and a troop of harlequins and scaramouches in the little open temple on the mount.

from *Letters*, to Sir H. Mann,
HORACE WALPOLE, 3 May 1749

ANTONELLO DA MESSINA
(active 1456; died 1479) Italian
Saint Jerome in his Study
about 1475

An arch never sleeps.

<div align="right">HINDUSTANI PROVERB</div>

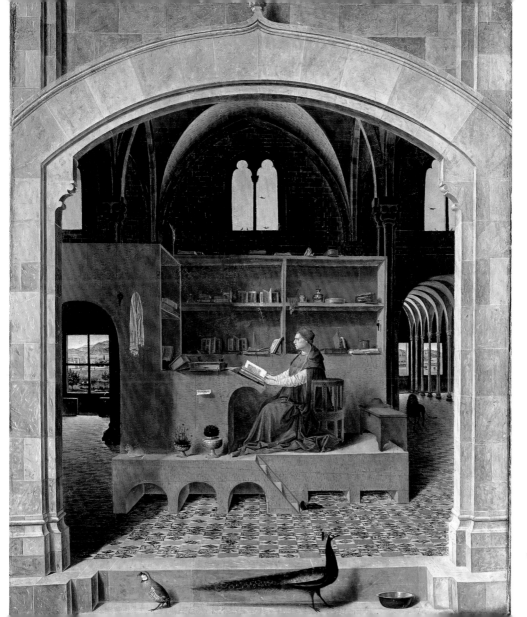

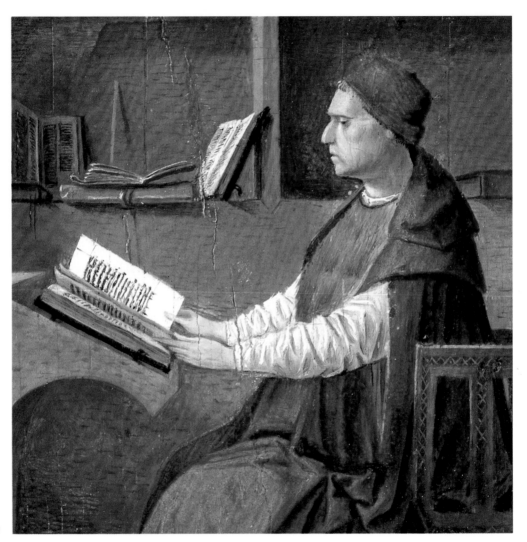

43

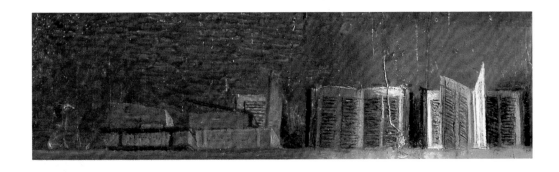

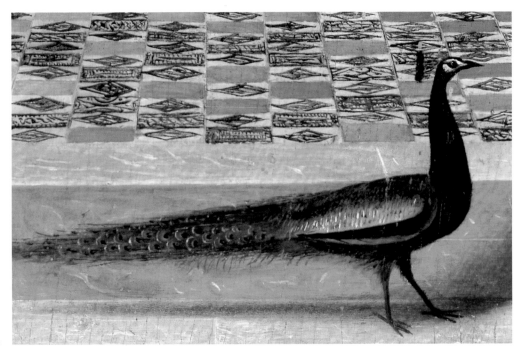

44

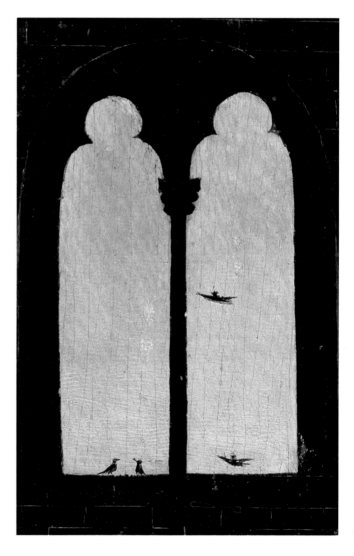

PIETER DE HOOCH (1629–1684) Dutch
The Courtyard of a House in Delft
1658

Oblique light on the trite, on the brick and tile—
Immaculate masonry, and everywhere that
Water tap, that broom and wooden pail
To keep it so. House-proud, the wives
Of artisans pursue their thrifty lives
Among scrubbed yards, modest but adequate.
Foliage is sparse, and clings. No breeze
Ruffles the trim composure of those trees.

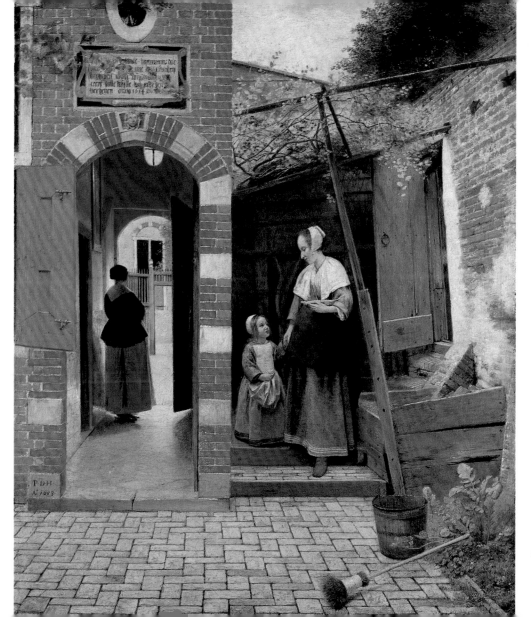

47

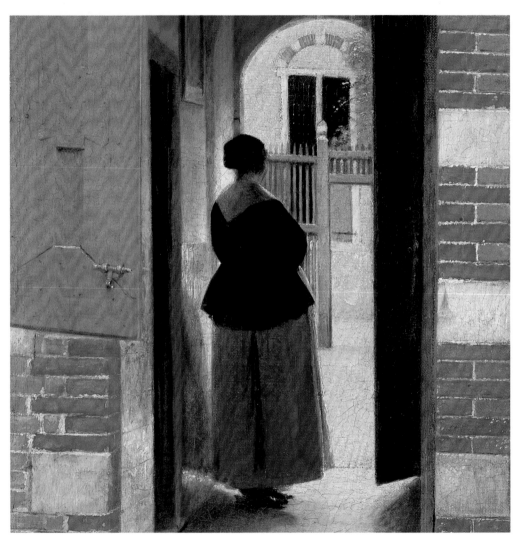

48

No spinet-playing emblematic of
The harmonies and disharmonies of love;
No lewd fish, no fruit, no wide-eyed bird
About to fly its cage while a virgin
Listens to her seducer, mars the chaste
Perfection of the thing and the thing made.
Nothing is random, nothing goes to waste.
We miss the dirty dog, the fiery gin.

That girl with her back to us who waits
For her man to come home for his tea
Will wait till the paint disintegrates
And ruined dikes admit the esurient sea;
Yet this life too, and the cracked
Out-house door a verifiable fact
As vividly mnemonic as the sunlit
Railings that front the houses opposite.

I lived there as a boy and know the coal
Glittering in its shed, late-afternoon
Lambency informing the deal table,
The ceiling cradled in a radiant spoon.
I must be lying low in a room there,
A strange child with a taste for verse,
While my hard-nosed companions dream of fire
And sword upon parched veldt and fields of rain-swept gorse.

from *Courtyards in Delft*,
DEREK MAHON, 1981 49

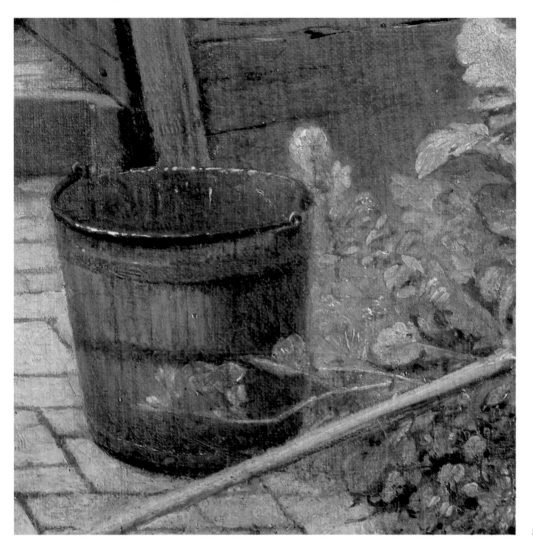

51

PAUL CÉZANNE (1839–1906) French
The Stove in the Studio
probably 1865–70

The water in one of the tubs was frozen solid, for it was
as cold inside the studio as it was out of doors, and, as
Mahoudeau had not a penny in his pocket for over a week
he was eking out the last of his coal by lighting the stove
only for an hour or two in the mornings. It was a sinister
sort of place, more like a funeral-vault than a studio, for
from its bare walls and cracked ceiling the cold wrapped
round one like a winding sheet...

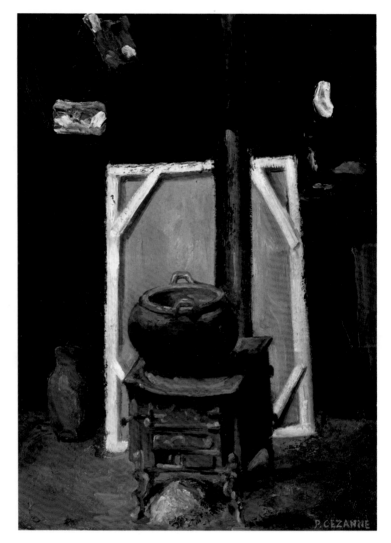

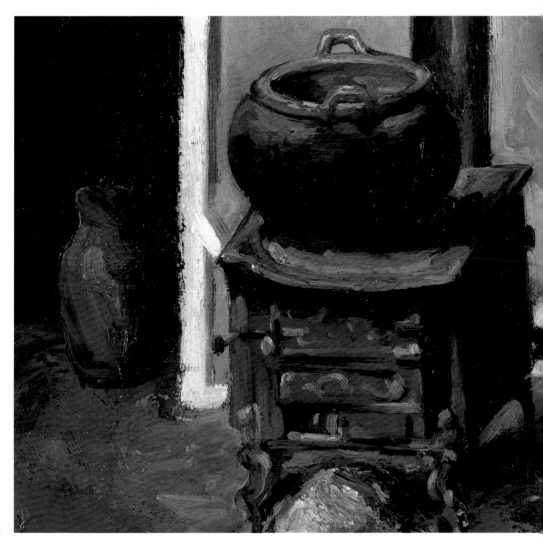

'How is the latest effort going?' said Claude.

'But for this damned cold it would be finished,' was the answer. 'Have a look.'

He straightened up, once he was sure the stove was drawing properly, and moved over to the middle of the room where, on a table made of a packing-case reinforced with struts, stood a statue swathed in old white dust-sheets frozen so stiff that they clung to it and revealed its lines as if they were a shroud…

The stove was getting red now and giving out tremendous heat, and the statue, which was quite close to it, seemed to be coming to life as the hot air swept up its back from its calves to the nape of its neck, while the two friends sat examining and discussing it in every detail, lingering over every line and curve of its body…

Suddenly the head dropped forward, the legs crumpled up and the statue began to fall forward in a living mass, with the same fearful anguish and the same rush of pain and despair as a woman flinging herself to her death…

'Good God! It's giving way! The bloody thing's collapsing.'

As it thawed the clay had broken the soft wood of the framework and it could be heard splitting and cracking like fractured bones.

from *The Masterpiece*,
ÉMILE ZOLA, 1886

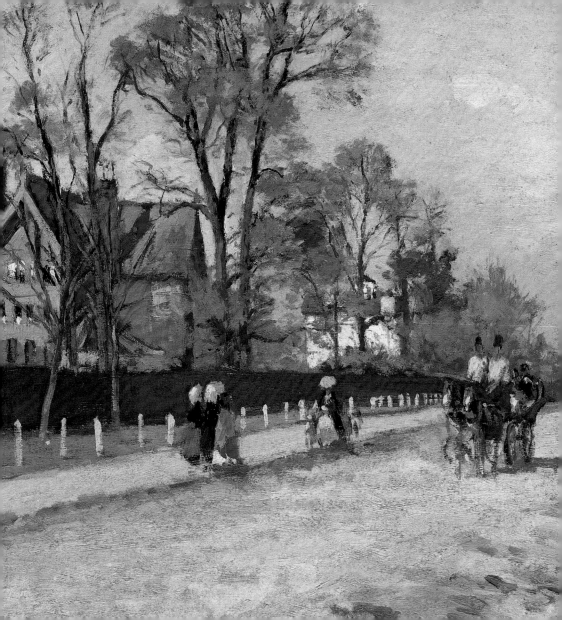

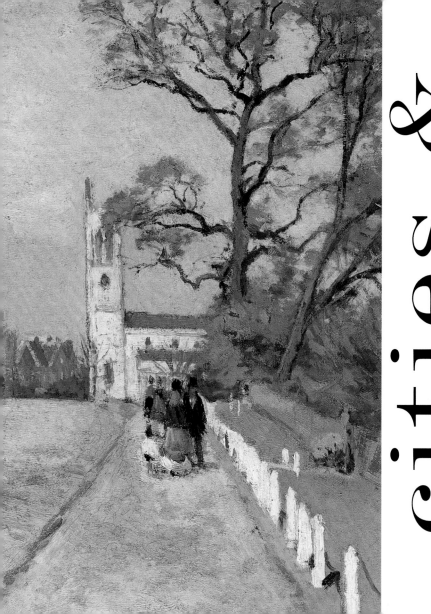

cities & streets

CAMILLE PISSARRO (1830–1903) French
The Boulevard Montmartre at Night
1897

The boulevard was all alive, brilliant with illuminations, with
the variety and gaiety of the crowd, the dazzle of shops and
cafés seen through uncovered fronts or immense lucid plates,
the flamboyant porches of theatres and the flashing lamps
of carriages, the far-spreading murmur of talkers and
strollers, the uproar of pleasure and prosperity, the general
magnificence of Paris…

The boulevard became even more brilliant as the evening
went on and Hyacinth wondered whether he had a right to
occupy the same table for so many hours. The theatre on the
other side discharged its multitude; the crowd thickened on
the wide asphalt, on the terrace of the café; gentlemen
accompanied by ladies of whom he knew already how to
characterise the type – *des femmes très chic* – passed into
the portals of Tortoni.

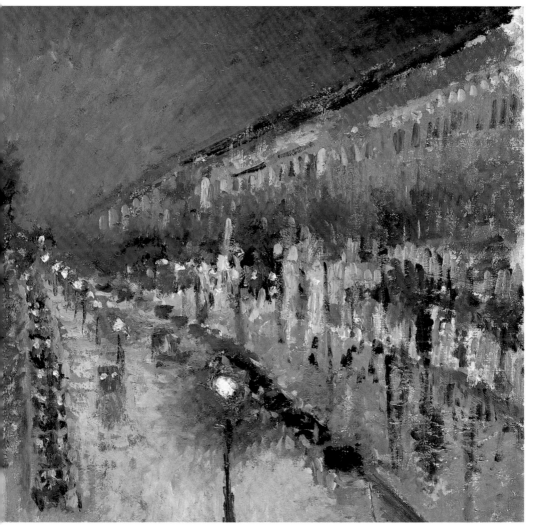

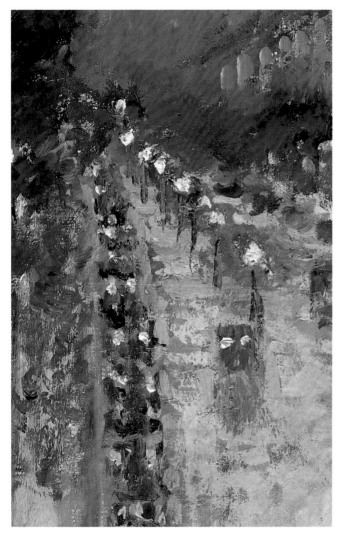

The nightly emanation of Paris seemed to rise more richly, to float and hang in the air, to mingle with the universal light and the many voiced sound, to resolve itself into a thousand solicitations and opportunities, addressed, however, mainly to those in whose pockets the chink of a little loose gold might respond. Hyacinth's retrospections had not made him drowsy, but quite the reverse; he grew restless and excited and a kind of pleasant terror of the place and hour entered into his blood. But it was nearly midnight and he got up to walk home, taking the line of the boulevard toward the Madeleine.

from *The Princess Casamassima*,
HENRY JAMES, 1886

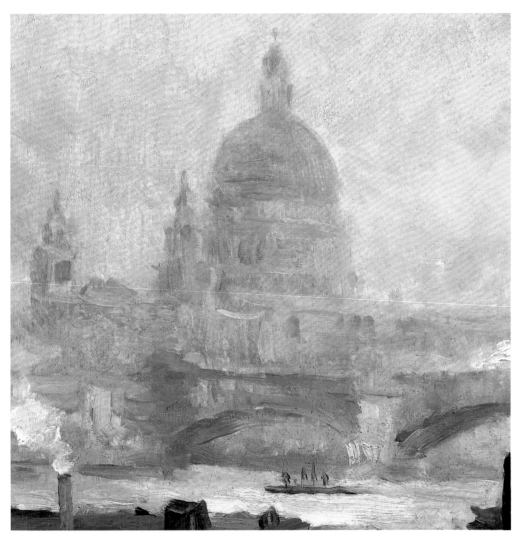

CHARLES-FRANÇOIS DAUBIGNY (1817–1878) French
St Paul's from the Surrey Side
1873

The next day was the first day of March, and when I awoke,
rose, and opened my curtain, I saw the risen sun struggling
through the fog. Above my head, above the house-tops,
co-elevate almost with the clouds, I saw a solemn, orbed mass,
dark-blue and dim – THE DOME. While I looked, my inner self
moved; my spirit shook its always-fettered wings half loose; I
had a sudden feeling as if I, who never yet truly lived, were at
last about to taste life...

Prodigious was the amount of life I lived that morning.
Finding myself before St. Paul's, I went in; I mounted to the
dome: I saw thence London, with its river, and its bridges,
and its churches; I saw antique Westminster, and the green
Temple Gardens, with sun upon them, and a glad, blue sky,
of early spring, above; and, between them and it, not too
dense a cloud of haze. Descending, I went wandering
whither chance might lead, in a still ecstasy of freedom and
enjoyment: and I got – I know not how – I got into the heart
of city life. I saw and felt London at last: I got into the Strand;
I went up Cornhill; I mixed with the life passing along; I
dared the perils of crossings. To do this, and to do it utterly
alone, gave me, perhaps an irrational, but a real pleasure.

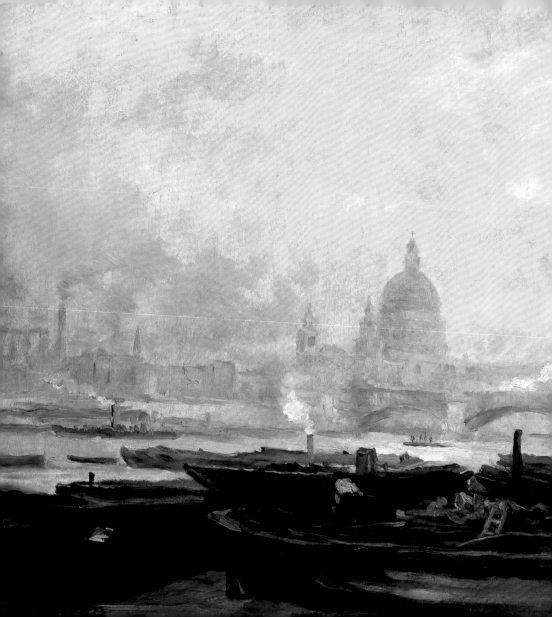

Since those days, I have seen the West
End, the parks, the fine squares; but I
love the City far better. The City seems
so much more in earnest: its business,
its rush, its roar, are such serious
things, sights, and sounds. The City is
getting its living – the West End but
enjoys its pleasure. At the West End you
may be amused, but in the City you are
deeply excited.

from *Villette*,
CHARLOTTE BRONTË, 1853

67

PAULUS CONSTANTIJN LA FARGUE
(1729–1782) Dutch
The Grote Markt at The Hague
1760

Buy a goose?
Any bellows to mend?
Who's for a mutton pie, or an eel pie?
Who buys my roasting jacks?
Sand, ho! buy my nice white sand, ho!
Buy my firestone?
Roasted pippins, piping hot!
A whole market hand for a halfpenny—young radishes, ho!
Sw-e-e-p!
Brick dust, today?
Door mats, want?
Hot rolls!
Rhubarb!
Buy any clove-water?
Quick periwinkles!
Sheep's trotters, hot!
Songs, three yards a penny!
Southernwood that's very good!
Cherries O! Ripe cherries O!
Cat's and dog's meat!
Samphire!
All a-growin', all a-blowin'.

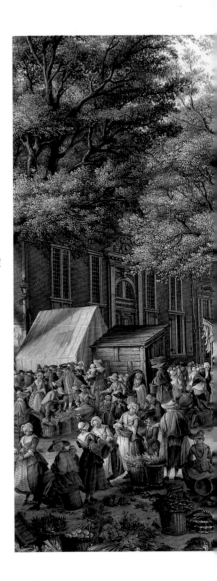

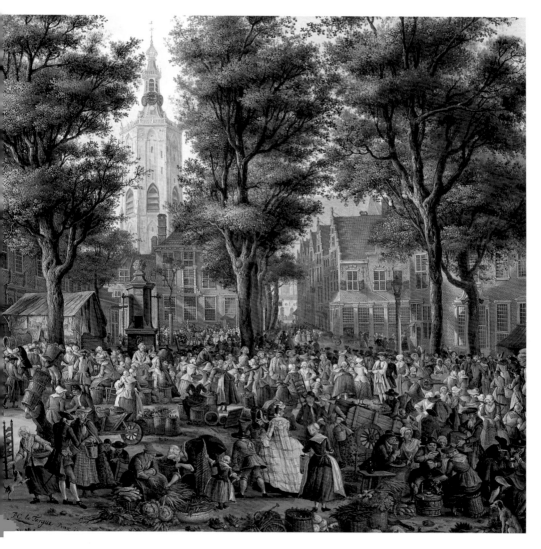

69

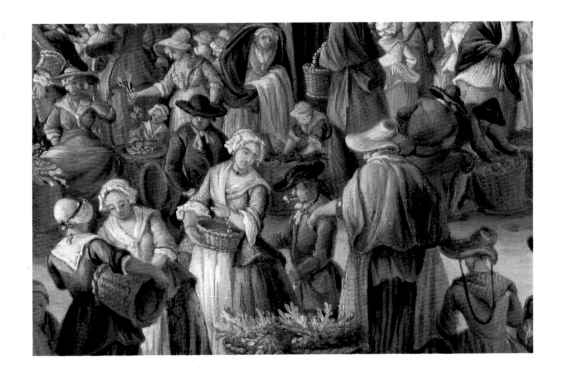

Lilly white mussels, penny a quart!
New Yorkshire muffins!
Oysters twelvepence a peck!
Rue, sage, and mint, farthing a bunch!
Tuppence a hundred cockles!
Sweet violets, a penny a bunch!

London Cries
ANONYMOUS, 18th century

71

CANALETTO (1697–1768) Italian
Venice: The Basin of San Marco on Ascension Day
about 1740

Once did She hold the gorgeous East in fee
And was the safeguard of the West; the worth
Of Venice did not fall below her birth,
Venice, the eldest child of Liberty.

She was a maiden city, bright and free;
No guile seduced, no force could violate;
And when she took unto herself a mate,
She must espouse the everlasting Sea.

And what if she had seen those glories fade,
Those titles vanish, and that strength decay;
Yet shall some tribute of regret be paid
When her long life hath reach'd its final day:
Men are we, and must grieve when even the shade
Of that which once was great is pass'd away.

On the Extinction of the Venetian Republic,
WILLIAM WORDSWORTH, 1802

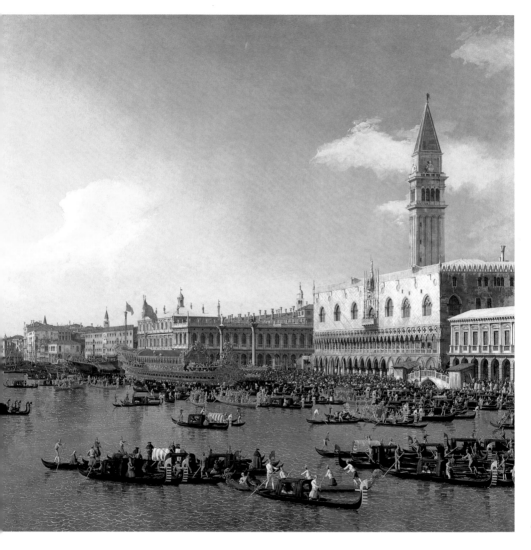

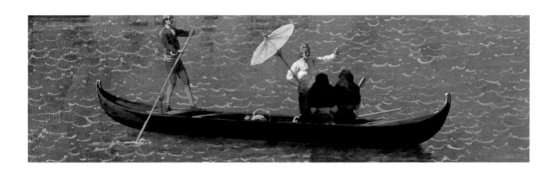

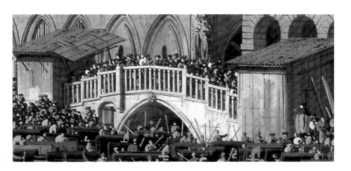

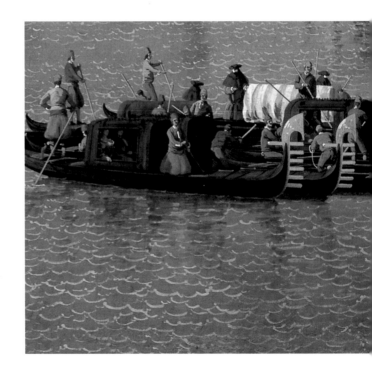

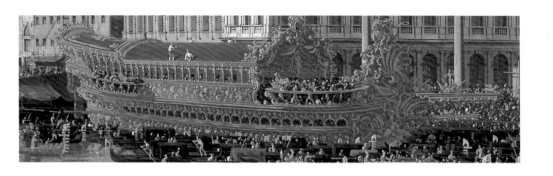

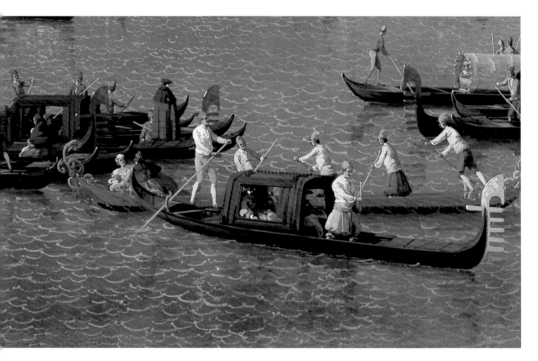

EDUARD GAERTNER
(1801–1877) German
The Friedrichsgracht,
Berlin
probably 1830s

From my window, the
deep solemn massive
street. Cellar-shops where
the lamps burn all day,
under the shadow of top-
heavy balconied façades,
dirty plaster frontages
embossed with scroll-work
and heraldic devices. The
whole district is like this:
street leading into street
of houses like shabby
monumental safes
crammed with the
tarnished valuables and
second-hand furniture of a
bankrupt middle class.

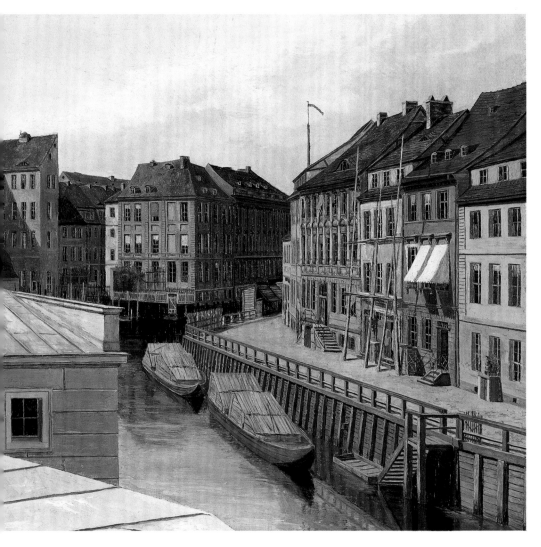

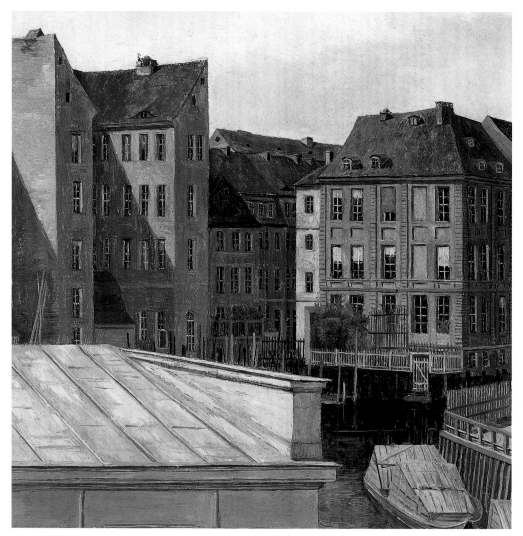

I am a camera with its shutter open, quite passive, recording, not thinking. Recording the man shaving at the window opposite and the woman in the kimono washing her hair. Some day, all this will have to be developed, carefully printed, fixed.

ffrom *Goodbye to Berlin*,
CHRISTOPHER ISHERWOOD, 1939

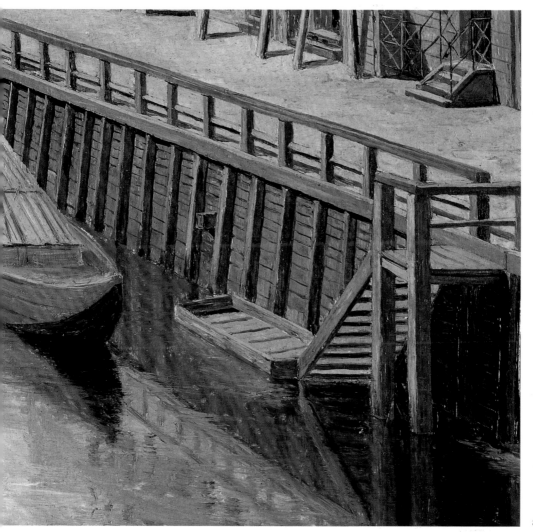

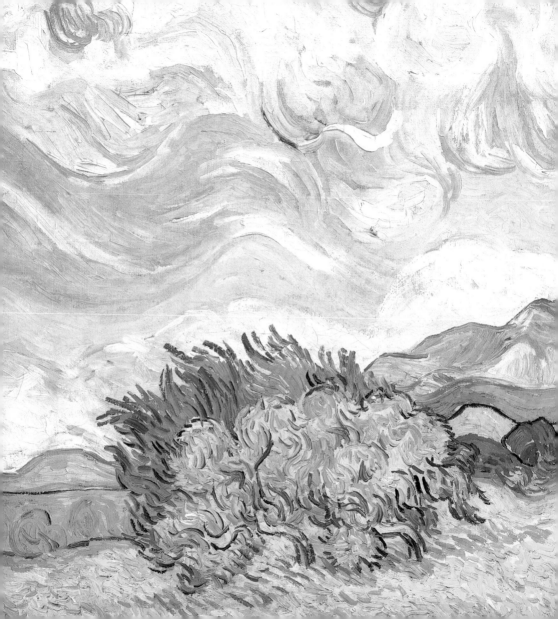

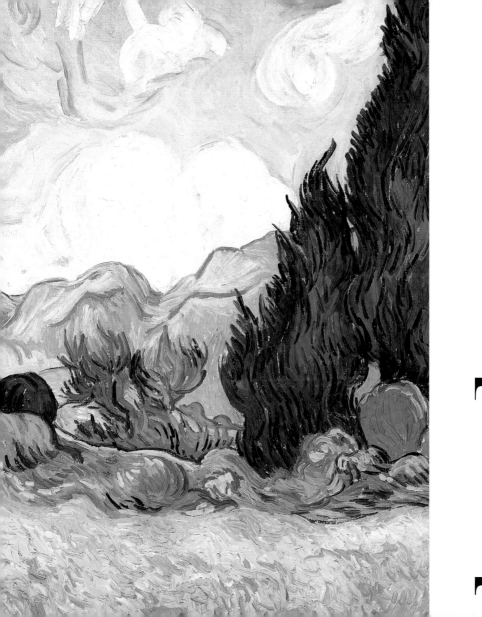

landscapes

HENDRICK AVERCAMP (1585–1634) Dutch
A Winter Scene with Skaters near a Castle
about 1608–09

On blithesome frolics bent, the youthful swains,
While every work of man is laid at rest,
Fond o'er the river crowd, in various sport
And revelry dissolved; where mixing glad,
Happiest of all the train! the raptured boy
Lashes the whirling top. Or, where the Rhine
Branched out in many a long canal extends,
From every province swarming, void of care,
Batavia rushes forth; and, as they sweep,
On sounding skates, a thousand different ways,
In circling poise, swift as the winds, along,
The then gay land is maddened all to joy.

from 'Winter', *The Seasons*,
JAMES THOMSON, 1726

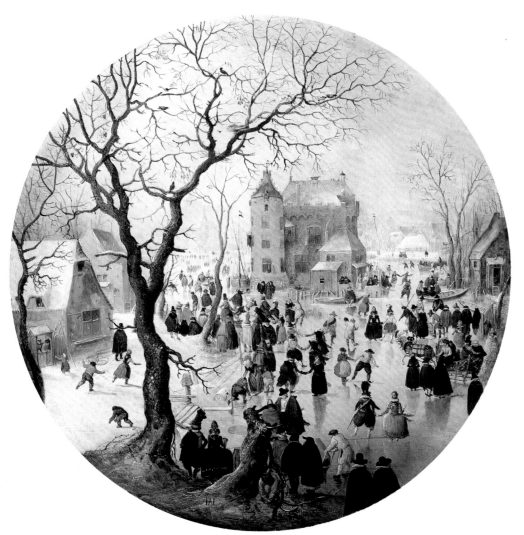

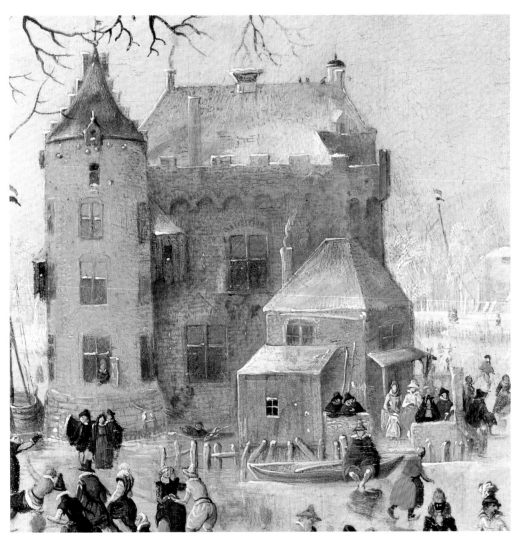

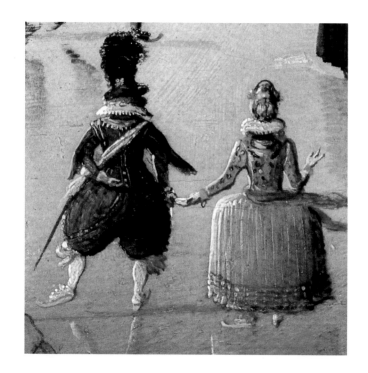

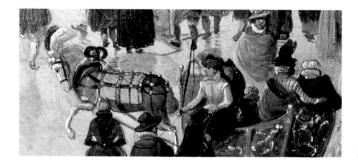

89

JOHN CONSTABLE (1776–1837) English
Salisbury Cathedral from the Meadows
1831

Glory be to God for dappled things—
 For skies as couple-coloured as a brindled cow;
 For rose-moles all in stipple upon trout that swim;
Fresh-firecoal chestnuts-falls; finches' wings;
 Landscapes plotted and pieced—fold, fallow and plough;
 And all trades, their gear and tackle and trim.
All things counter, original, spare, strange;
 Whatever is fickle, freckled (who knows how?)
 With swift, slow; sweet, sour; adazzle, dim;
He fathers-forth whose beauty is past change:
 Praise Him.

Pied Beauty
GERARD MANLEY HOPKINS, 1877

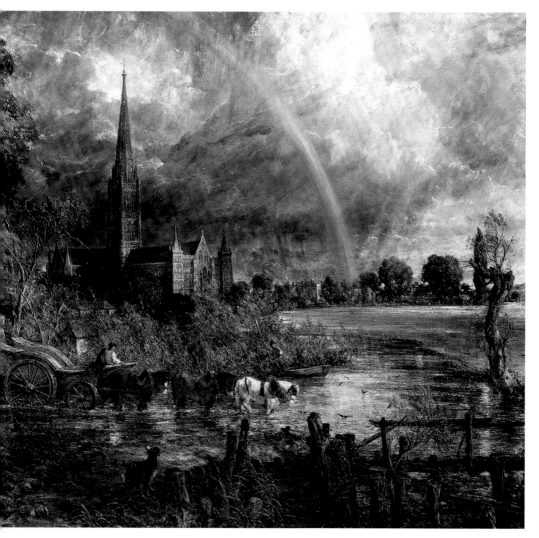

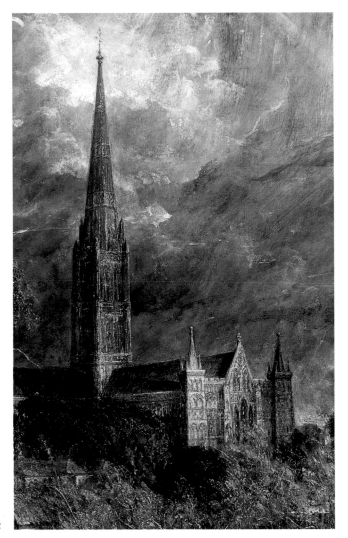

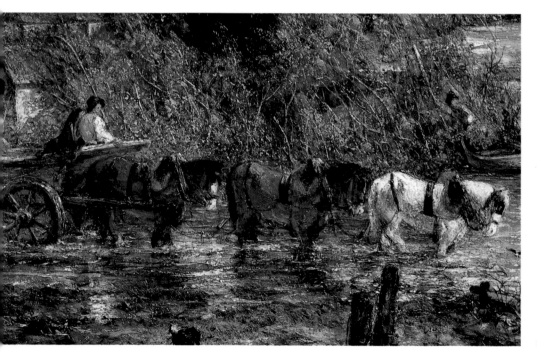

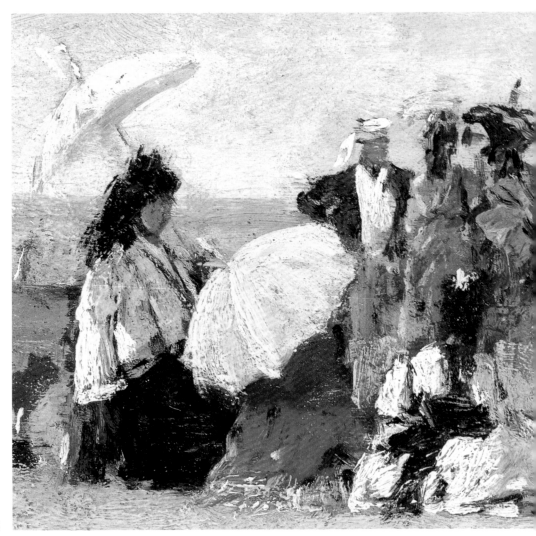

94

EUGÈNE BOUDIN (1824–1898) French
Beach Scene, Trouville
1873

I remember the sea when I was six
and ran on wetted sands
that were speckled with shells and the blowholes of clams
bedded secretly down in black muck—

I remember the sun, fishy airs, rotting piers
that reached far out into turquoise waters,
and ladies in white who sprinkled light laughter
from under their parasols....

Where was it, that beach whose hot sand I troweled
day after day into my red tin pail?
It's only in dreams now I sense it, unreal,
at the end of an inner road no longer traveled.

"I remember the sea when I was six...",
FREDERICK MORGAN, 1981

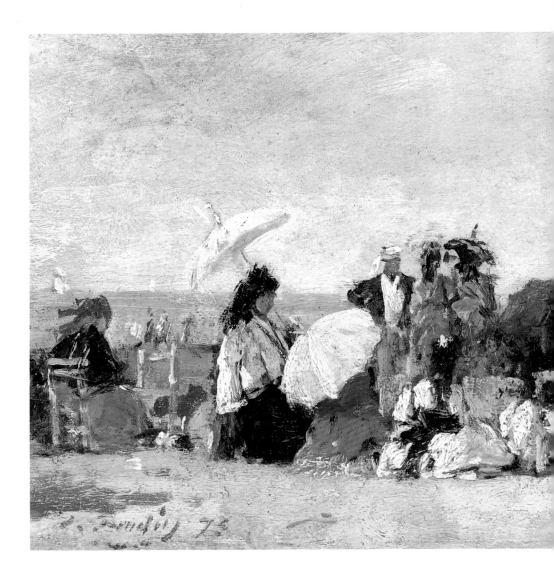

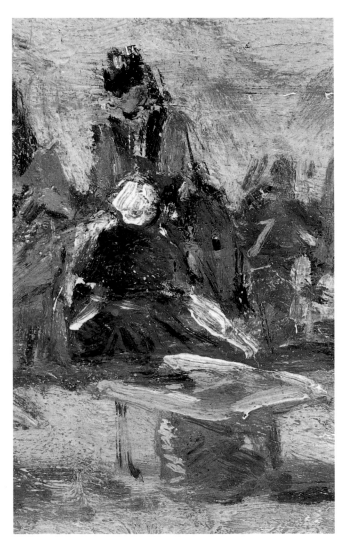

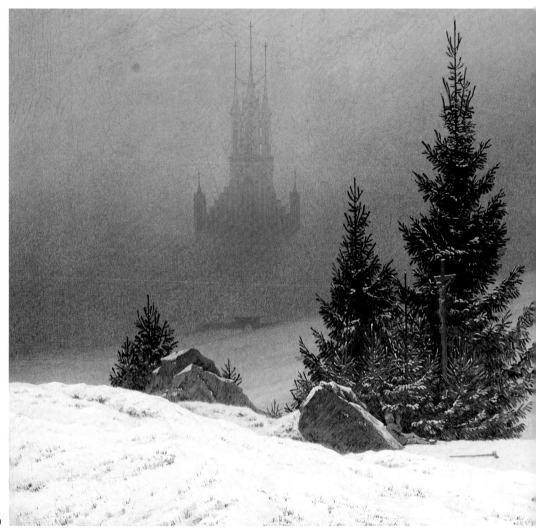

CASPAR DAVID FRIEDRICH (1774–1840) German
Winter Landscape
probably 1811

The winter comes I walk alone
I want no birds to sing
To those who keep their hearts their own
The winter is the Spring
No flowers to please—no bees to hum
The coming Springs already come

I never want the christmas rose
To come before its time
The seasons each as God bestows
Are simple and sublime
I love to see the snow storm hing
'Tis but the winter garb of Spring

I never want the grass to bloom
The snow-storm's best in white
I love to see the tempest come
And love its piercing light
The dazzled eyes that love to cling
O'er snow white meadows sees the Spring

I love the snow the crimpling snow
That hangs on every thing,
It covers every thing below
Like white doves brooding wing
A landscape to the aching sight
A vast expance of dazzling light

It is the foliage of the woods
That winter's bring—The dress
White easter of the year in bud
That makes the winter Spring
The frost and snow his poseys bring
Natures white spirits of the Spring

The Winters Spring,
JOHN CLARE, 1847

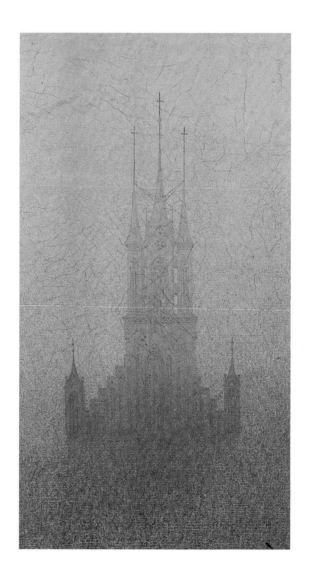

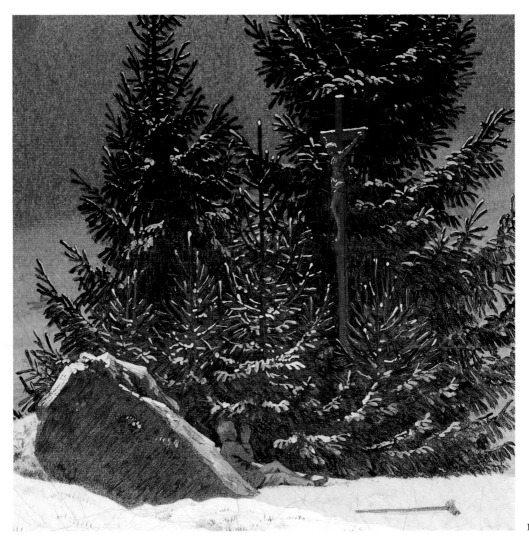

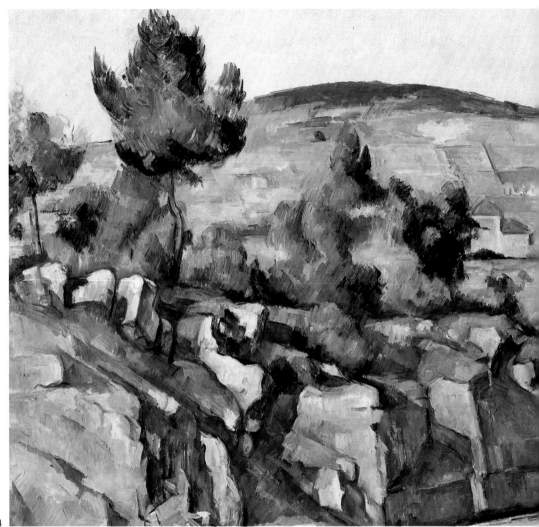

PAUL CÉZANNE (1839–1906) French
Hillside in Provence
probably about 1886–90

We are now between the Lion d'Or and Salon, on the famous
Plaine de Crau, or Plain of Stones, one vast mass of pebbles,
which cover the country for several leagues, and reduce it to
utter barrenness…We are now in the midst of this plain of
stones, utter desolation on every side, the magnificent line of
the Alpines, as they are called, or Provence mountains,
stretching on our left; and on our right, close by the
roadside, runs full and fresh and lively, a stream of water,
one of the channels of irrigation brought forth from the
Durance, and truly giving life to a thirsty land. 'He maketh
the wilderness a running water,' might be said truly of this
life in the midst of death. Here are two houses just built by
the roadside, and opposite to them a little patch of ground
just verdured, surrounded by a little belt of cypresses and
willows; now, again, all is desolate – all but the living stream
on our right, and some sheep wandering on the left amidst
the stones, and living one sees not how. The sun has just set
over this vast plain, just as at sea.

from *Correspondence*,
THOMAS ARNOLD, 1839

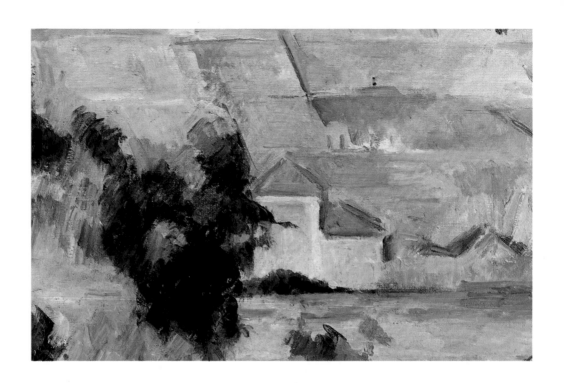

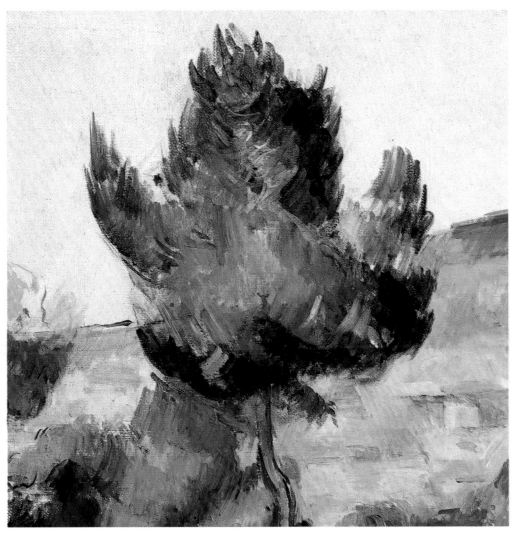

PETER PAUL RUBENS (1577–1640) Flemish
An Autumn Landscape with a View of
Het Steen in the Early Morning
probably 1636

Season of mists and mellow fruitfulness!
 Close bosom-friend of the maturing sun;
Conspiring with him how to load and bless
 With fruit the vines that round the thatch-eaves run;
To bend with apples the mossed cottage-trees,
 And fill all fruit with ripeness to the core;
 To swell the gourd, and plump the hazel shells
 With a sweet kernel; to set budding more,
And still more, later flowers for the bees,
Until they think warm days will never cease,
 For summer has o'er-brimmed their clammy cells.

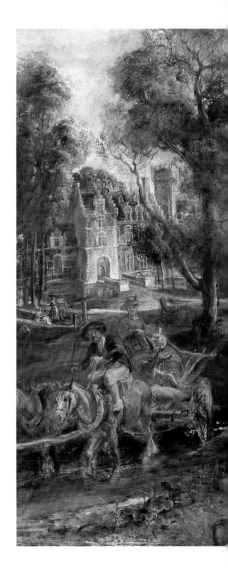

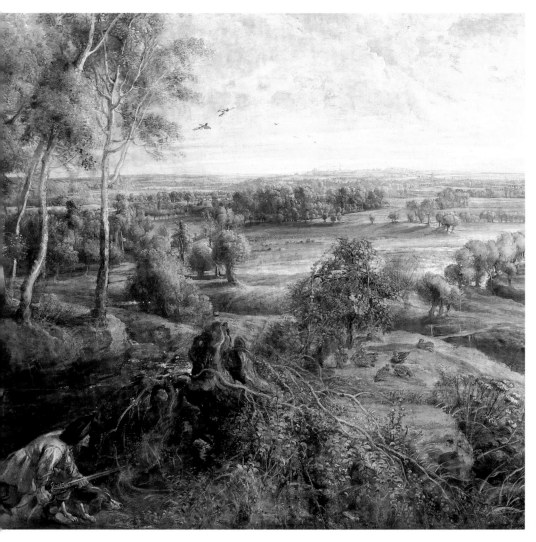

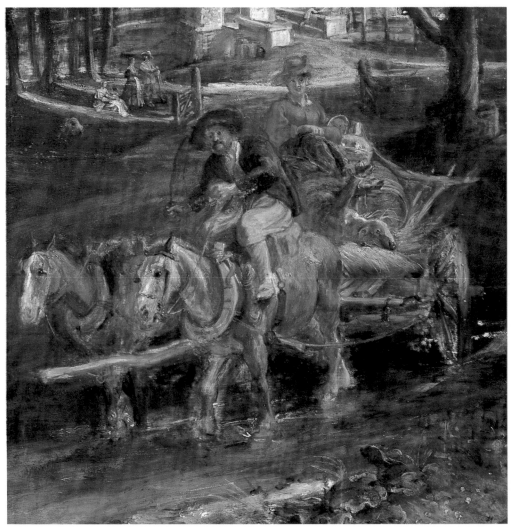

110

Who hath not seen thee oft amid thy store?
 Sometimes whoever seeks abroad may find
Thee sitting careless on a granary floor,
 Thy hair soft-lifted by the winnowing wind;
Or on a half-reaped furrow sound asleep,
 Drowsed with the fume of poppies, while thy hook
 Spares the next swath and all its twinèd flowers;
And sometimes like a gleaner thou dost keep
 Steady thy laden head across a brook;
 Or by a cider-press, with patient look,
 Thou watchest the last oozings hours by hours.

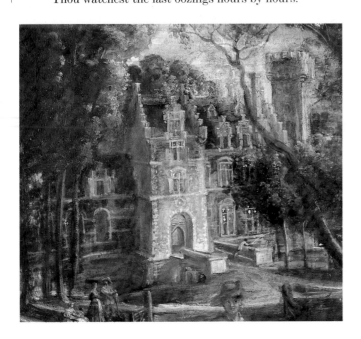

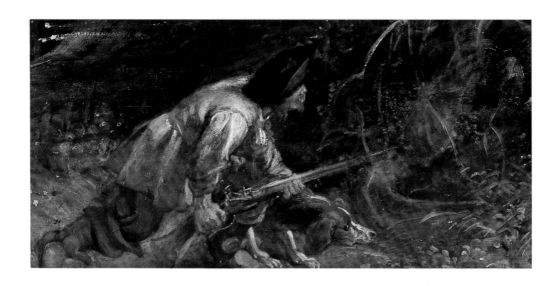

Where are the songs of Spring? Aye, where are they?
　　Think not of them, thou hast thy music too,—
While barrèd clouds bloom the soft-dying day,
　　And touch the stubble-plains with rosy hue;
Then in a wailful choir, the small gnats mourn
　　Among the river sallows, borne aloft
　　　　Or sinking as the light wind lives or dies;
And full-grown lambs loud bleat from hilly bourn;
　　Hedge-crickets sing; and now with treble soft
　　The redbreast whistles from a garden-croft;
　　　　And gathering swallows twitter in the skies.

To Autumn,
JOHN KEATS, 1819

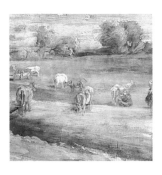

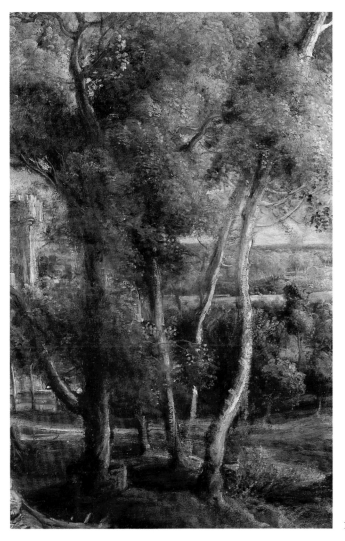

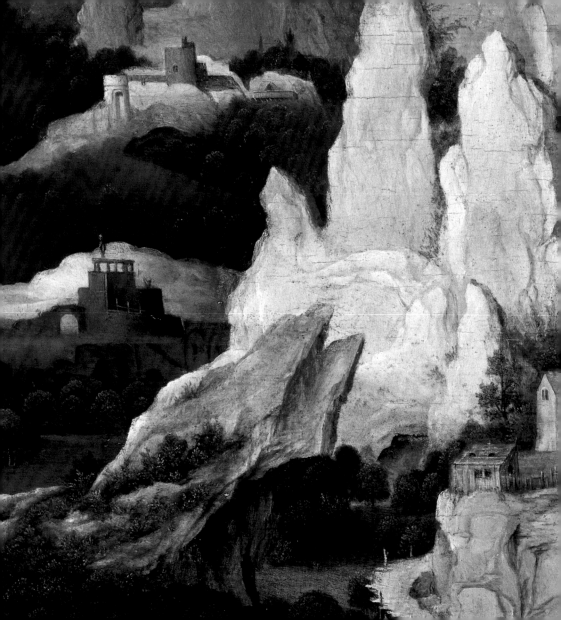

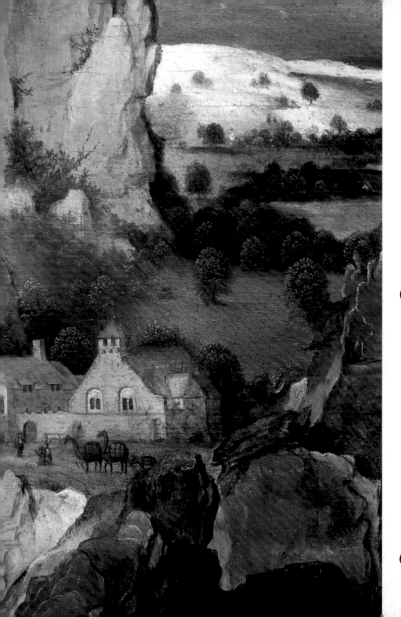

imaginary places

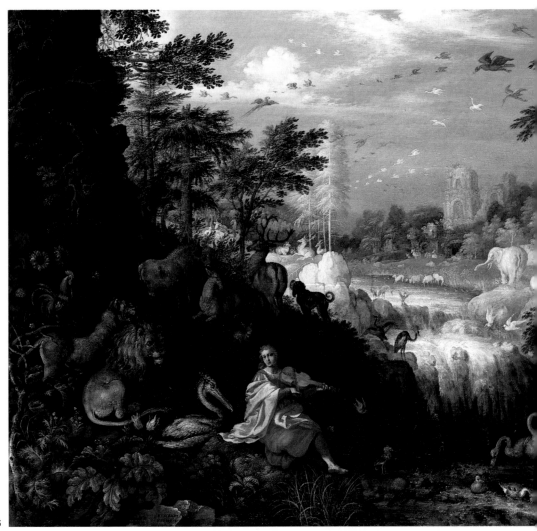

ROELANDT SAVERY (1576–1639) Flemish
Orpheus
1628

On the top of a certain hill was a level stretch of open
ground, covered with green turf. There was no shelter
from the sun, but when the divinely-born poet seated
himself there and struck his melodious strings, shady
trees moved to the spot. The oak tree of Chaonia and
poplars, Phaethon's sisters, crowded round, along
with Jupiter's great oak, with its lofty branches, and
soft lime trees and beeches, and the virgin laurel,
brittle hazels, and ash trees, that are used for spear
shafts, smooth firs and the holm oak, bowed down
with acorns, the genial sycamore, and the variegated
maple, willows that grow by the rivers and the water-
loving lotus, evergreen box, slender tamarisks,
myrtles double-hued, and viburnum with its dark blue
berries. There was ivy too, trailing its tendrils, and
leafy vines, vine-clad elms and mountain ash, pitch-
pine and wild strawberry, laden with rosy fruit, wav-
ing palms, the victor's prize, and the pine, its leaves
gathered up into a shaggy crest, the favourite tree of
Cybele, the mother of the gods.

from *Metamorphoses*,
OVID, 1st century AD

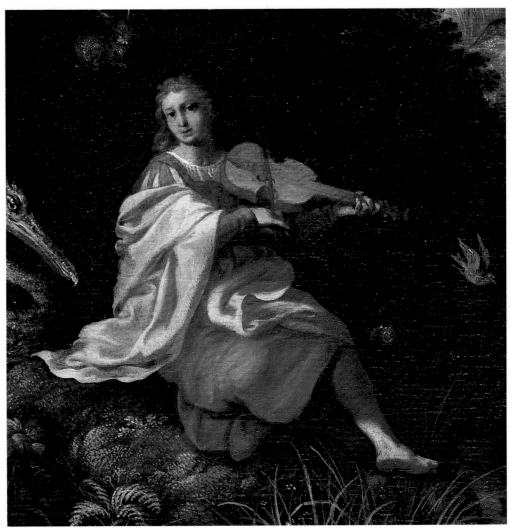

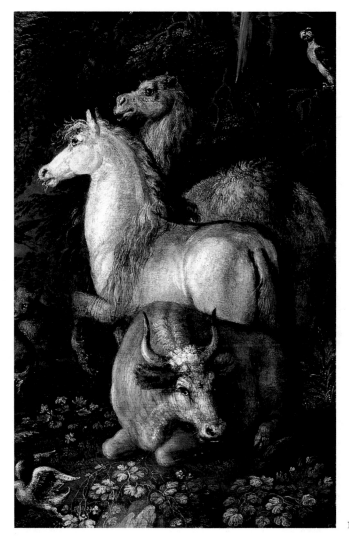

119

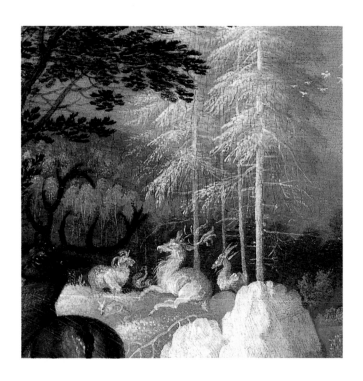

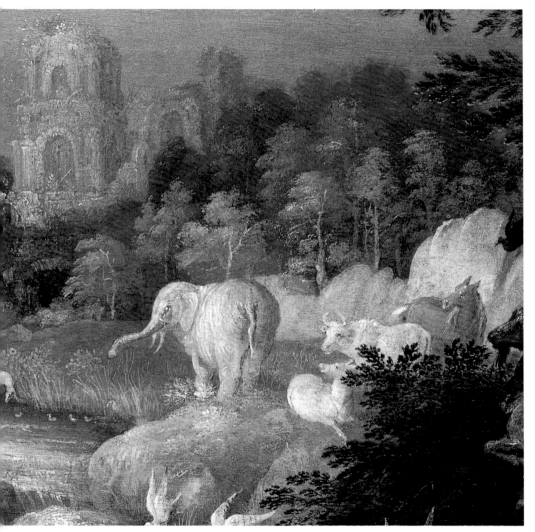

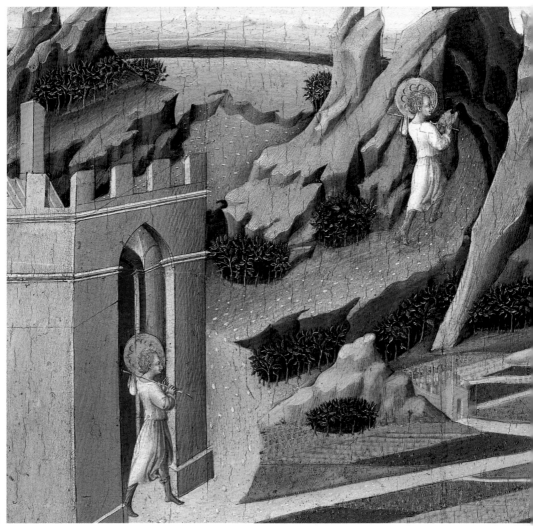

GIOVANNI DI PAOLO (active by 1417; died 1482) Italian
Saint John the Baptist retiring to the Desert
probably about 1453

... the word of God came to John son of Zachariah in the
wilderness. And he went all over the Jordan valley
proclaiming a baptism in token of repentance for the
forgiveness of sins, as it is written in the book of the
prophecies of Isaiah:

> 'A voice crying aloud in the wilderness
> "Prepare a way for the Lord;
> clear a straight path for him.
> Every ravine shall be filled in,
> and every mountain and hill levelled;
> the corners shall be straightened,
> and the rugged ways made smooth;
> and all mankind shall see God's deliverance." '

LUKE III.2–6

124

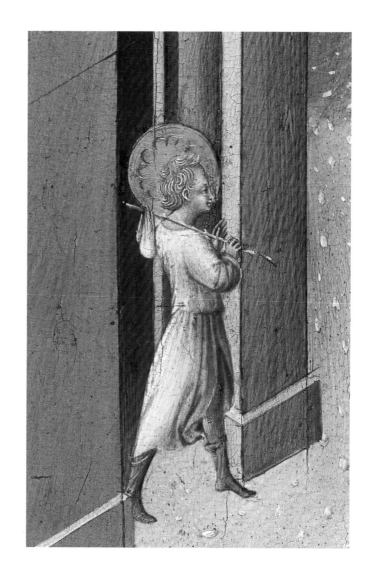

125

CLAUDE (1604/5?–1682) French

Seaport with the Embarkation of the Queen of Sheba
1648

The Queen of Sheba heard of Solomon's fame and came to test him with hard questions. She arrived in Jerusalem with a very large retinue, camels laden with spices, gold in great quantity, and precious stones. When she came to Solomon, she told him everything she had in her mind, and Solomon answered all her questions; not one of them was too abstruse for the King to answer. When the Queen of Sheba saw all the wisdom of Solomon, the house which he had built, the food on his table, the courtiers sitting round him, and his attendants standing behind in their livery, his cupbearers, and the whole-offerings which he used to offer in the house of the Lord, there was no more spirit left in her. Then she said to the King, 'The report which I heard in my own country about you and your wisdom was true, but I did not believe it until I came and saw for myself. Indeed I was not told half of it; your wisdom and your prosperity go far beyond the report which I had of them. Happy are your wives, happy are these courtiers of yours who wait on you every day and hear your wisdom! Blessed be the Lord your

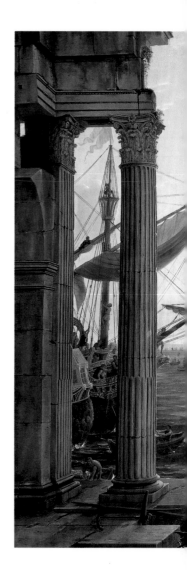

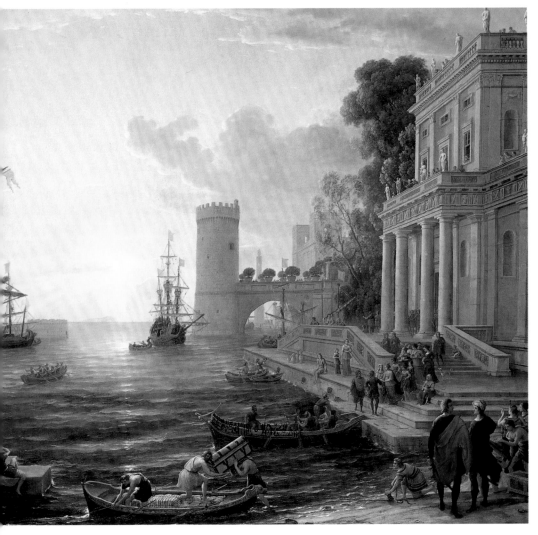

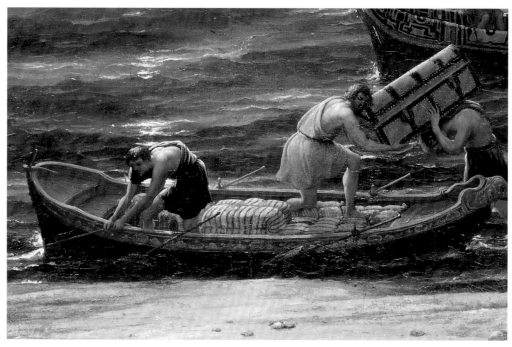

God who has delighted in you and has set you on the throne of Israel; because he loves Israel for ever, and has made you their King to maintain law and justice.' Then she gave the King a hundred and twenty talents of gold, spices in great abundance, and precious stones. Never again came such a quantity of spices as the Queen of Sheba gave to King Solomon.

1 KINGS X.1–11

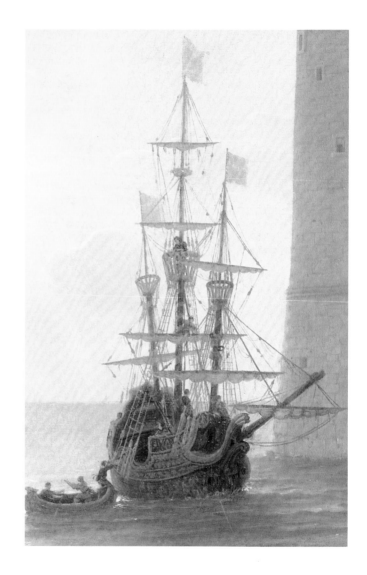

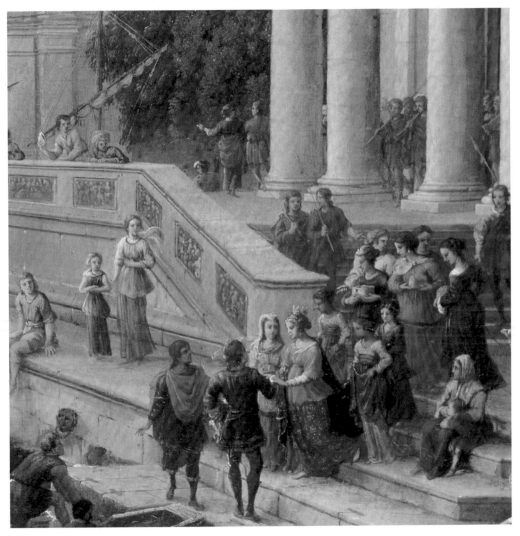

131

FRANÇOIS DE NOMÉ (about 1593–after 1630) French
Fantastic Ruins with Saint Augustine and the Child
1623

Around Golgonooza lies the land of death eternal, a Land
Of pain and misery and despair and ever brooding melancholy
In all the Twenty-seven heavens, number'd from Adam to Luther,
From the blue Mundane Shell, reaching to the Vegetative Earth.

The Vegetative Universe opens like a flower from Earth's center
In which is Eternity. It expands in Stars to the Mundane Shell
And there it meets Eternity again, both within and without,
And the abstract Voids between the Stars are the Satanic Wheels.

There is the Cave, the Rock, the Tree, the Lake of Udan Adan,
The Forest and the Marsh and the Pits of bitumen deadly,
The Rocks of solid fire, the Ice valleys, the Plains
Of burning sand, the rivers, cataract & Lakes of Fire,
The Islands of the fiery Lakes, the Trees of Malice, Revenge
And black Anxiety, and the Cities of the Salamandrine men,
(But whatever is visible to the Generated Man
Is a Creation of mercy & love from the Satanic Void).
The land of darkness flamed, but no light & no repose:

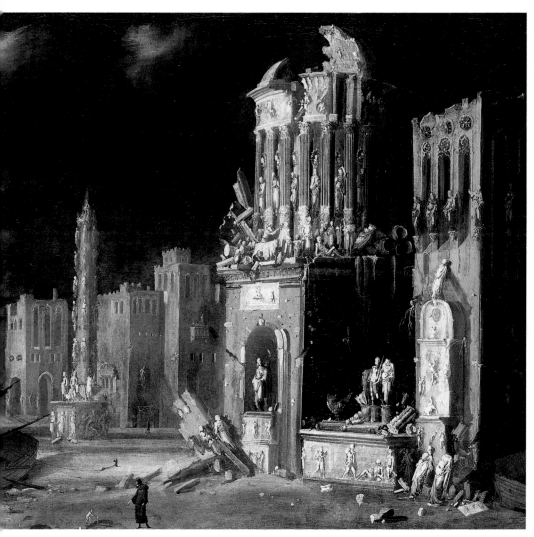

133

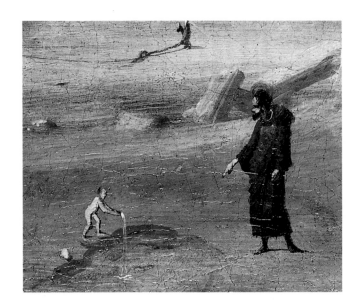

The land of snows of trembling & of iron hail incessant:
The land of earthquakes, and the land of woven labyrinths:
The land of snares & traps & wheels & pit-falls & dire mills:
The Voids, the Solids, & the land of clouds & regions of
 waters
With their inhabitants, in the Twenty-seven Heavens
 beneath Beulah:
Self-righteousness conglomerating against the Divine Vision:
A Concave Earth wondrous, Chasmal, Abyssal, Incoherent…

from *Jerusalem*,
WILLIAM BLAKE, 1804–20

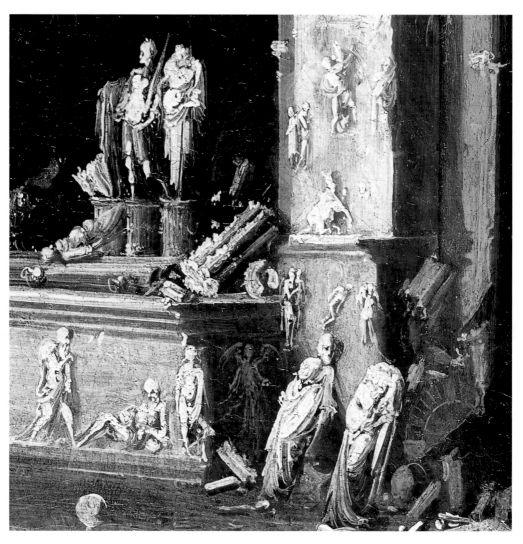

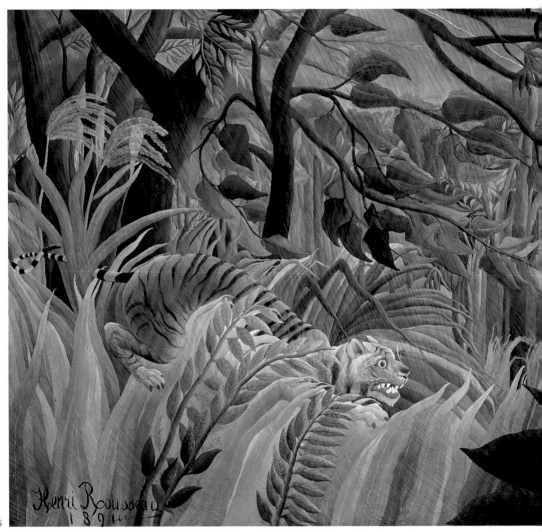

HENRI ROUSSEAU (1844–1910) French
Tiger in a Tropical Storm (Surprised!)
1891

True, what he felt was no more than a longing to travel; yet coming upon him with such suddenness and passion as to resemble a seizure, almost a hallucination. Desire projected itself visually: his fancy, not quite yet lulled since morning, imaged the marvels and terrors of the manifold earth. He saw. He beheld a landscape, a tropical marshland, beneath a reeking sky, steaming, monstrous, rank – a kind of primeval wilderness-world of islands, morasses, and alluvial channels. Hairy palm-trunks rose near and far out of lush brakes of fern, out of the bottoms of crass vegetation, fat, swollen, thick with incredible bloom. There were trees, mis-shapen as a dream, that dropped their naked roots straight through the air into the ground or into water that was stagnant and shadowy and glassy-green, where mammoth milk-white blossoms floated, and strange high-shouldered birds with curious bills stood gazing sidewise without sound or stir. Among the knotted joints of a bamboo thicket the eyes of a crouching tiger gleamed – and he felt his heart throb with terror yet with a longing inexplicable.

from *Death in Venice*,
THOMAS MANN, 1912

ARTISTS & PAINTINGS

ANTONELLO da Messina
Saint Jerome in his Study,
oil (identified) on lime,
45.7 x 36.2 cm, p.41

AVERCAMP, Hendrick
*A Winter Scene with Skaters
near a Castle,*
oil on oak,
diameter 40.7 cm, p.87

BERCKHEYDE, Gerrit
*The Interior of the Grote Kerk,
Haarlem,*
oil on oak,
60.8 x 84.9 cm, p.34

BORSSUM, Anthonie van
*A Garden Scene with
Waterfowl,*
oil on canvas,
33.7 x 45.8 cm, p.30

BOUDIN, Eugène
Beach Scene, Trouville,
oil on wood,
15.2 x 29.8 cm, p.96

CANALETTO
*Venice: The Basin of San
Marco on Ascension Day,*
oil on canvas,
121.9 x 182.8 cm, p.73

*London: Interior of the
Rotunda at Ranelagh,*
oil on canvas,
47 x 75.6 cm, p.37

CÉZANNE, Paul
Hillside in Provence,
oil (identified) on canvas,
63.5 x 79.4 cm, p.104

Landscape with Poplars,
oil on canvas,
71 x 58 cm, cover

The Stove in the Studio,
oil on canvas,
41 x 30 cm, p.53

CLAUDE
*Seaport with the
Embarkation of the Queen of
Sheba,*
oil (identified) on canvas,
148.6 x 193.7 cm, p.127

CONSTABLE, John
*Salisbury Cathedral from the
Meadows,*
oil on canvas,
151.8 x 189.9 cm, p.91

DAUBIGNY, Charles-François
*St Paul's from the Surrey
Side,*
oil on oak (?),
44 x 81.3 cm, p.64

ECKERSBERG, Christoffer
Wilhelm
View of the Forum in Rome,
oil on canvas,
32 x 41 cm, p.2

FRIEDRICH, Caspar David
Winter Landscape,
oil (identified) on canvas,
32.5 x 45 cm, p.100

GAERTNER, Eduard
The Friedrichsgracht, Berlin,
oil on paper laid down on
millboard,
25.5 x 44.6 cm, p.79

GIOVANNI di Paolo
*Saint John the Baptist
retiring to the Desert,*
tempera on poplar,
31.1 x 38.8 cm, p.122

GOGH, Vincent van
A Wheatfield, with Cypresses,
oil (identified) on canvas,
72.1 x 90.9 cm, p.84

HARPIGNIES, Henri-Joseph
The Painter's Garden at Saint-Privé,
oil on canvas,
59.7 x 81.3 cm, p.8

HOOCH, Pieter de
The Courtyard of a House in Delft,
oil on canvas,
73.5 x 60 cm, p.47

LA FARGUE, Paulus Constantijn
The Grote Markt at The Hague,
oil on mahogany,
57.6 x 75.9 cm, p.69

LANCRET, Nicolas
A Lady in a Garden taking Coffee with some Children,
oil on canvas,
88.9 x 97.8 cm, p.20

MANET, Edouard
Music in the Tuileries Gardens,
oil (identified) on canvas,
76.2 x 118.1 cm, p.11

MONET, Claude-Oscar
Bathers at La Grenouillère,
oil (identified) on canvas,
73 x 92 cm, p.16

NOMÉ, François de
Fantastic Ruins with Saint Augustine and the Child,
oil on canvas,
45.1 x 66 cm, p.133

PATINIR, Joachim
Attributed to, *Saint Jerome in a Rocky Landscape,*
oil on oak,
36.2 x 34.3 cm, p.114

PISSARRO, Camille
The Avenue, Sydenham,
oil (identified) on canvas,
48 x 73 cm, p.56

The Boulevard Montmartre at Night,
oil on canvas,
53.3 x 64.8 cm, p.59

ROUSSEAU, Henri
Tiger in a Tropical Storm (Surprised!),
oil on canvas,
129.8 x 161.9 cm, p.136

RUBENS, Peter Paul
An Autumn Landscape with a View of Het Steen in the Early Morning,
oil on oak,
131.2 x 229.2 cm, p.109

SAVERY, Roelandt
Orpheus,
oil on oak,
53 x 81.5 cm, p.116

SCHONGAUER, Martin
Style of, *The Virgin and Child in a Garden,*
oil (identified) on lime,
30.2 x 21.9 cm, p.27

WRITERS & WORKS

ANONYMOUS
Hindustani proverb, p.40

London cries, English
18th century, p.68

ARNOLD, Thomas
(1795–1842) English
Correspondence, 1839, p.105

BAUDELAIRE, Charles
(1821–1867) French
The Painter of Modern Life,
1863, p.10

BIBLE
1 Kings X. l–ll, p.126

Luke III. 2–6, p.123

BLAKE, William
(1757–1827) English
Jerusalem, 1804–20, p.132

BRONTË, Charlotte
(1816–1855) English
Villette, 1853, p.63

BRYANT, William Cullen
(1794–1878) American
To a Waterfowl, 1818, p.31

CLARE, John
(1793–1864) English
The Winters Spring, 1847, p.101

HOPKINS, Gerard Manley
(1844–1889) English
Pied Beauty, 1877, p.90

Rosa Mystica, 1875, p.26

ISHERWOOD, Christopher
(1904–1986) English
Goodbye to Berlin, 1939, p.78

JAMES, Henry
(1843–1916) American
The Princess Casamassima,
1886, p.58

KEATS, John
(1795–1821) English
To Autumn, 1819, p.108

MAHON, Derek
(b.1941) Irish
Courtyards in Delft, 1981, p.46

MANN, Thomas
(1875–1955) German
Death in Venice, 1912, p.137

MAUPASSANT, Guy de
(1850–1893) French
A Picnic in the Country, 1881,
p.16

MORGAN, Frederick
(b.1922) American
*"I remember the sea when I
was six...",* 1981, p.95

OVID
(43BC–AD18) Roman
Metamorphoses,
1st century AD, p.117

ROUSSEAU, Jean-Jacques
(1712–1778) Swiss
Julie, ou la Nouvelle Héloïse,
1761, p.21

THOMSON, James
(1700–1748) English
'Winter', *The Seasons,* 1726,
p.86

WALPOLE , Horace
(1717–1797) English
Letters, to Sir H. Mann,
3 May 1749, p.36

WORDSWORTH, William
(1770–1850) English
*On the Extinction of the
Venetian Republic,* 1802,
p.72

ZOLA, Émile
(1840–1902) French
The Masterpiece, 1886, p.52

ACKNOWLEDGMENTS

The editor and publishers gratefully acknowledge permission to reprint copyright material listed below. Every effort has been made to contact the original copyholders of the material included. Any omissions will be rectified in future editions.

excerpt from *The Painter of Modern Life* by Charles Baudelaire, translated by. Jonathan Mayne (1964) by permission of Phaidon Press Ltd.

excerpt from *Goodbye to Berlin* by Christopher Isherwood, published by Chatto & Windus. Reproduced with permission of Curtis Brown Ltd., London, on behalf of the Estate of Christopher Isherwood. Copyright Christopher Isherwood.

Courtyards in Delft: ©Derek Mahon 1982. Reprinted from 'The Hunt by Night' by Derek Mahon (1982) by permission of Oxford University Press.

excerpt from *A Picnic in the Country* by Guy de Maupassant from 'The Mountain Inn and Other Stories', translated by H.N.P. Soloman (Penguin Classics, 1955) copyright © H.N.P. Soloman, 1955. Reproduced by permission of Penguin Books Ltd.

excerpt from *Death in Venice* by Thomas Mann, translated by H. T. Lowe-Porter by kind permission of Random House, Inc.

"I remember the sea when I was six..." by Frederick Morgan from 'Poems: New and Selected'. Copyright 1987 by Frederick Morgan. Used with the permission of the author and the University of Illinois Press.

excerpt from *The Masterpiece:* © Roger Pearson 1993. Reprinted from 'The Masterpiece' by Émile Zola translated by Thomas Walton, revised and edited by Roger Pearson (1993), by permission of Oxford University Press.

Giovanni di Paolo: detail *Saint John the Baptist retiring to the Desert*

Title page: Christoffer
Wilhelm Eckersberg, *View
of the Forum in Rome*,
1814

Parks & Gardens title page:
Henri-Joseph Harpignies,
*The Painter's Garden at
Saint-Privé*, 1886

Interiors title page: Gerrit
Berckheyde, *The Interior of
the Grote Kerk, Haarlem*,
1673

Cities & Streets title page:
Camille Pissarro, *The
Avenue, Sydenham*, 1871

Landscapes title page:
Vincent van Gogh, *A
Wheatfield, with Cypresses*,
1889

Imaginary Places title page:
Attributed to Joachim
Patinir, *Saint Jerome in a
Rocky Landscape*, probably
1515-24